SPECULATIVE EVERYTHING

SPECULATIVE EVERYTHING

DESIGN, FICTION, AND SOCIAL DREAMING

ANTHONY DUNNE & FIONA RABY

THE MIT PRESS
CAMBRIDGE, MASSACHUSETTS
LONDON, ENGLAND

MIT Press books may be purchased at special quantity discounts for business or sales promotional use. For information, please email special_sales@mitpress.mit.edu.

This book was set in Letter Text and Chlotz by the MIT Press. Art direction and typeface by Kellenberger-White. Printed and bound in the United States of America.

Library of Congress Cataloging-in-Publication Data

Dunne, Anthony.
 Speculative everything : design, fiction, and social dreaming /
by Anthony Dunne and Fiona Raby.
 pages cm
 Includes bibliographical references and index.
 ISBN 978-0-262-01984-2 (hardcover : alk. paper)
1. Design—Philosophy. I. Raby, Fiona. II. Title.
NK1505.D865 2013
745.4—dc23
2013009801

10 9 8 7 6 5

CONTENTS

PREFACE

Speculative Everything began as a list we created a few years ago called *A/B*, a sort of manifesto. In it, we juxtaposed design as it is usually understood with the kind of design we found ourselves doing. *B* was not intended to replace *A* but to simply add another dimension, something to compare it to and facilitate discussion. Ideally, *C, D, E,* and many others would follow.

This book unpacks the *B* bit of the list, making connections between usually disparate ideas, locating them within an expanded notion of contemporary design practice, and establishing some historical links. It is not a straightforward survey, anthology of essays, or monograph but offers a very specific view of design based on several years of experimentation, teaching, and reflection. We use examples from our own practice, student and graduate work from the Royal College of Art, and other projects from fine art, design, architecture, cinema, and photography. In researching this book we also surveyed literature from futurology, cinematic and literary fiction, political theory, and the philosophy of technology.

The ideas in this book move from a general setting out of what conceptual design is, through its use as a critical medium for exploring the implications of new developments in science and technology, to the aesthetics of crafting speculative designs. It ends by zooming out to explore the idea of "speculative everything" and design as a catalyst for social dreaming.

Speculative Everything is an intentionally eclectic and idiosyncratic journey through an emerging cultural landscape of ideas, ideals, and approaches. We hope designers interested in doing more than making technology easy to use, sexy, and consumable will find this book enjoyable, stimulating and inspiring.

A	B
Affirmative	Critical
Problem solving	Problem finding
Provides answers	Asks questions
Design for production	Design for debate
Design as solution	Design as medium
In the service of industry	In the service of society
Fictional functions	Functional fictions
For how the world is	For how the world could be
Change the world to suit us	Change us to suit the world
Science fiction	Social fiction
Futures	Parallel worlds
The "real" real	The "unreal" real
Narratives of production	Narratives of consumption
Applications	Implications
Fun	Humor
Innovation	Provocation
Concept design	Conceptual design
Consumer	Citizen
Makes us buy	Makes us think
Ergonomics	Rhetoric
User-friendliness	Ethics
Process	Authorship

A/B, Dunne & Raby.

ACKNOWLEDGMENTS

The ideas in this book have taken shape over many years through conversations and exchanges with many people. We would like to thank the following in particular for their support and help throughout the development of this project.

Our teaching activities at the Royal College of Art (RCA) in London are a constant source of inspiration; we are privileged to work with supremely talented students whose projects never cease to challenge and push our own thinking. In Design Products, we would like to thank Platform 3, Durrell Bishop, Onkar Kular, Ron Arad, and Hilary French; in Architecture, ADS4, Gerrard O'Carroll and Nicola Koller; and more recently, the amazingly talented staff and students of the Design Interactions program, particularly James Auger, Noam Toran, Nina Pope, Tom Hulbert, David Muth, Tobie Kerridge, Elio Caccavale, David Benqué and Sascha Pohflepp; as well as a very long list of guests who have dropped by and generously shared their ideas and thoughts in lectures and critiques. We are extremely grateful to the RCA for being the sort of place where it is not only possible to develop work and ideas like this but it is also actively encouraged and supported.

We have always believed in the importance of discussing and developing ideas in a broader context than academia alone, and thank in particular Wendy March at Intel and Alex Taylor at Microsoft Research Cambridge for bringing an industry perspective to our research; Paul Freemont and Kirsten Jensen at Imperial College, London, for their support and encouragement in our explorations into synthetic biology and other areas of science; and the many people who have provided opportunities to share our thinking through talks, workshops, and conferences and to benefit from the challenges, questions, and discussions they have sparked. We are also thankful for the generosity and enthusiasm of the people and organizations who have commissioned and exhibited our work making it possible to engage with a wider public audience. In particular, Michael John Gorman at The Science Gallery; Jan Boelen at Z33; Constance Rubin and the Saint-Etienne International Design Biennial; James Peto and Ken Arnold at The Wellcome Trust; Deyan Sudjic, Nina Due, and Alex Newson at the Design Museum in London; and especially Paola Antonelli at the Museum of Modern Art in New York for her inspiring and passionate commitment to making more room in the world for design like this.

Over the last few years we have enjoyed a rich and ongoing exchange of ideas around interactions between design, fiction, science, technology, and

futures with a number of people we would like to thank: Bruce Sterling, Oron Catts, Jamer Hunt, David Crowley, Stuart Candy, and Alexandra Midal.

And of course, we are very grateful to Doug Sery, our editor at MIT Press, for taking on this project and his enthusiastic support and encouragement throughout its development. For the smooth and enjoyable process of putting everything together we'd like to thank the brilliant team at the MIT Press for being so patient and accommodating, especially Katie Helke Doshina for steering us through the production process, designer Erin Hasley, and Deborah Cantor-Adams for editing.

We're very grateful to everyone who provided images for the book, and to Elizabeth Glickfeld for her dedicated detective work and picture research as well as Marcia Caines and Akira Suzuki for local picture sourcing. Finally, we'd like to thank Kellenberger-White for their graphic design advice and designing a special typeface for this book.

I.

BEYOND RADICAL DESIGN?

Dreams are powerful. They are repositories of our desire. They animate the entertainment industry and drive consumption. They can blind people to reality and provide cover for political horror. But they can also inspire us to imagine that things could be radically different than they are today, and then believe we can progress toward that imaginary world.[1]

It is hard to say what today's dreams are; it seems they have been downgraded to hopes—hope that we will not allow ourselves to become extinct, hope that we can feed the starving, hope that there will be room for us all on this tiny planet. There are no more visions. We don't know how to fix the planet and ensure our survival. We are just hopeful.

As Fredric Jameson famously remarked, it is now easier for us to imagine the end of the world than an alternative to capitalism. Yet alternatives are exactly what we need. We need to dream new dreams for the twenty-first century as those of the twentieth century rapidly fade. But what role can design play?

When people think of design, most believe it is about problem solving. Even the more expressive forms of design are about solving aesthetic problems. Faced with huge challenges such as overpopulation, water shortages, and climate change, designers feel an overpowering urge to work together to fix them, as though they can be broken down, quantified, and solved. Design's inherent optimism leaves no alternative but it is becoming clear that many of the challenges we face today are unfixable and that the only way to overcome them is by changing our values, beliefs, attitudes, and behavior. Although essential most of the time, design's inbuilt optimism can greatly complicate things, first, as a form of denial that the problems we face are more serious than they appear, and second, by channeling energy and resources into fiddling with the world out there rather than the ideas and attitudes inside our heads that shape the world out there.

Rather than giving up altogether, though, there are other possibilities for design: one is to use design as a means of speculating how things could be—speculative design. This form of design thrives on imagination and aims to open up new perspectives on what are sometimes called *wicked problems*, to create spaces for discussion and debate about alternative ways of being, and to inspire and encourage people's imaginations to flow freely. Design speculations can act as a catalyst for collectively redefining our relationship to reality.

PROBABLE/PLAUSIBLE/POSSIBLE/PREFERABLE

Being involved with science and technology and working with many technology companies, we regularly encounter thinking about futures, especially about "The Future." Usually it is concerned with predicting or forecasting the future, sometimes it is about new trends and identifying weak signals that can be extrapolated into the near future, but it is always about trying to pin the future down. This is something we are absolutely not interested in; when it comes to technology, future predictions have been proven wrong again and again. In our view, it is a pointless activity. What we are interested in, though, is the idea of possible futures and using them as tools to better understand the present and to discuss the kind of future people want, and,

of course, ones people do not want. They usually take the form of scenarios, often starting with a what-if question, and are intended to open up spaces of debate and discussion; therefore, they are by necessity provocative, intentionally simplified, and fictional. Their fictional nature requires viewers to suspend their disbelief and allow their imaginations to wander, to momentarily forget how things are now, and wonder about how things could be. We rarely develop scenarios that suggest how things *should* be because it becomes too didactic and even moralistic. For us futures are not a destination or something to be strived for but a medium to aid imaginative thought—to speculate with. Not just about the future but about today as well, and this is where they become critique, especially when they highlight limitations that can be removed and loosen, even just a bit, reality's grip on our imagination.

As all design to some extent is future oriented, we are very interested in positioning design speculation in relation to futurology, speculative culture including literature and cinema, fine art, and radical social science concerned with changing reality rather than simply describing it or maintaining it.[2] This space lies somewhere between reality and the impossible and to operate in it effectively, as a designer, requires new design roles, contexts, and methods. It relates to ideas about progress—change for the better but, of course, *better* means different things to different people.

To find inspiration for speculating through design we need to look beyond design to the methodological playgrounds of cinema, literature, science, ethics, politics, and art; to explore, hybridize, borrow, and embrace the many tools available for crafting not only things but also ideas—fictional worlds, cautionary tales, what-if scenarios, thought experiments, counterfactuals, reductio ad absurdum experiments, prefigurative futures, and so on.

In 2009, the futurologist Stuart Candy visited the Design Interactions program at the Royal College of Art and used a fascinating diagram in his presentation to illustrate different kinds of potential futures.[3] It consisted of a number of cones fanning out from the present into the future. Each cone represented different levels of likelihood. We were very taken by this imperfect but helpful diagram and adapted it for our own purposes.

The first cone was the probable. This is where most designers operate. It describes what is likely to happen unless there is some extreme upheaval such as a financial crash, eco disaster, or war. Most design methods, processes, tools, acknowledged good practice, and even design education are oriented toward this space. How designs are evaluated is also closely linked to a thorough understanding of probable futures, although it is rarely expressed in those terms.

The next cone describes plausible futures. This is the space of scenario planning and foresight, the space of what could happen. In the 1970s companies such as Royal Dutch Shell developed techniques for modeling alternative near-future global situations to ensure that they would survive through a number of large-scale, global, economic, or political shifts. The space of plausible futures is not about prediction but exploring alternative economic and political futures to ensure an organization will be prepared for and thrive in a number of different futures.

The next cone is the possible. The skill here is making links between today's world and the suggested one. Michio Kaku's book *Physics of the Impossible*[4] sets out three classes of impossibility, and even in the third, the most extreme—things that are not possible according to our current understanding of science—there are only two, perpetual motion and precognition, which, based on our current understanding of science, are impossible. All other changes—political, social, economic, and cultural— are not impossible but it can be difficult to imagine how we would get from here to there. In the scenarios we develop we believe, first, they should be scientifically possible, and second, there should be a path from where we are today to where we are in the scenario. A believable series of events that led to the new situation is necessary, even if entirely fictional. This allows viewers to relate the scenario to their own world and to use it as an aid for critical reflection. This is the space of speculative culture—writing, cinema, science fiction, social fiction, and so on. Although speculative, experts are often consulted when building these scenarios, as David Kirby points out in a fascinating chapter about distinctions between what he calls speculative scenarios and fantastic science in his book *Lab Coats in Hollywood*; the role of the expert is often, not to prevent the impossible but to make it acceptable.[5]

Beyond this lies the zone of fantasy, an area we have little interest in. Fantasy exists in its own world, with very few if any links to the world we live in. It is of course valuable, especially as a form of entertainment, but for us, it is too removed from how the world is. This is the space of fairy tales, goblins, superheroes, and space opera.

A final cone intersects the probable and plausible. This is the cone of preferable futures. Of course the idea of preferable is not so straightforward; what does *preferable* mean, for whom, and who decides? Currently, it is determined by government and industry, and although we play a role as consumers and voters, it is a limited one. In *Imaginary Futures*, Richard Barbrook explores futures as tools designed for organizing and

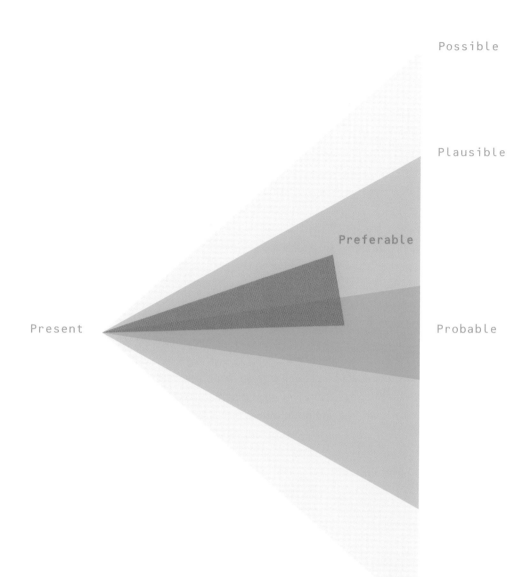

Possible

Plausible

Preferable

Present

Probable

PPPP. Illustration by Dunne & Raby.

justifying the present in the interests of a powerful minority.[6] But, assuming it is possible to create more socially constructive imaginary futures, could design help people participate more actively as citizen-consumers? And if so, how?

This is the bit we are interested in. Not in trying to predict the future but in using design to open up all sorts of possibilities that can be discussed, debated, and used to collectively define a preferable future for a given group of people: from companies, to cities, to societies. Designers should not define futures for everyone else but working with experts, including ethicists, political scientists, economists, and so on, generate futures that act as catalysts for public debate and discussion about the kinds of futures people really want. Design can give experts permission to let their imaginations flow freely, give material expression to the insights generated, ground these imaginings in everyday situations, and provide platforms for further collaborative speculation.

We believe that by speculating more, at all levels of society, and exploring alternative scenarios, reality will become more malleable and, although the future cannot be predicted, we can help set in place today factors that will increase the probability of more desirable futures happening. And equally, factors that may lead to undesirable futures can be spotted early on and addressed or at least limited.

BEYOND RADICAL DESIGN?

We have long been inspired by radical architecture and fine art that use speculation for critical and provocative purposes, particularly projects from the 1960s and 1970s by studios such as Archigram, Archizoom, Superstudio, Ant Farm, Haus-Rucker-Co, and Walter Pichler.[7] But why is this so rare in design? During the Cold War Modern exhibition at the Victoria and Albert Museum in 2008 we were delighted to finally see so many projects from this period for real. The exuberant energy and visionary imagination of the projects in the final room of the exhibition were incredibly inspiring for us. We were left wondering how this spirit could be reintroduced to contemporary design and how design's boundaries could be extended beyond the strictly commercial to embrace the extreme, the imaginative, and the inspiring.

We believe several key changes have happened since the high point of radical design in the 1970s that make imaginative, social, and political speculation today more difficult and less likely. First, during the 1980s design became hyper-commercialized to such an extent that alternative roles for

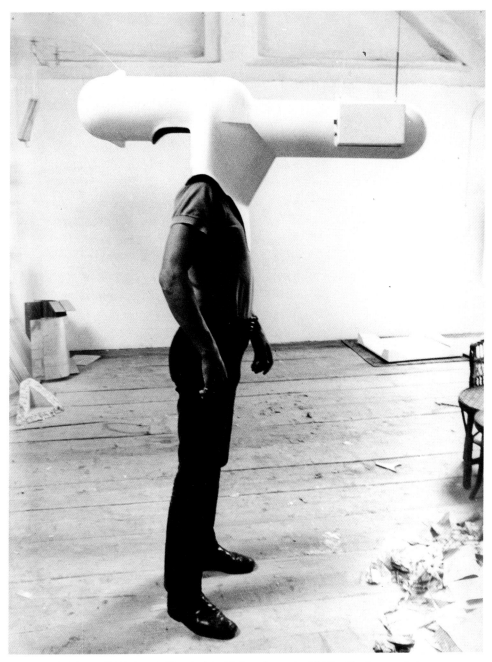

Walter Pichler, *TV Helmet (Portable Living Room)*, 1967. Photograph by
Georg Mladek. Photograph courtesy of Galerie Elisabeth and Klaus Thoman/
Walter Pichler.

design were lost. Socially oriented designers such as Victor Papanek who were celebrated in the 1970s were no longer regarded as interesting; they were seen as out of sync with design's potential to generate wealth and to provide a layer of designer gloss to every aspect of our daily lives. There was some good in this—design was embraced by big business and entered the mainstream but usually only in the most superficial way. Design became fully integrated into the neoliberal model of capitalism that emerged during the 1980s, and all other possibilities for design were soon viewed as economically unviable and therefore irrelevant.

Second, with the fall of the Berlin Wall in 1989 and the end of the Cold War the possibility of other ways of being and alternative models for society collapsed as well. Market-led capitalism had won and reality instantly shrank, becoming one dimensional. There were no longer other social or political possibilities beyond capitalism for design to align itself with. Anything that did not fit was dismissed as fantasy, as unreal. At that moment, the "real" expanded and swallowed up whole continents of social imagination marginalizing as fantasy whatever was left. As Margaret Thatcher famously said, "There is no alternative."

Third, society has become more atomized. As Zygmunt Bauman writes in *Liquid Modernity*,[8] we have become a society of individuals. People work where work is available, travel to study, move about more, and live away from their families. There has been a gradual shift in the United Kingdom from government that looks after the most vulnerable in society to a small government that places more responsibility on individuals to manage their own lives. On the one hand this undoubtedly creates freedom and liberation for those who wish to create new enterprises and projects but it also minimizes the safety net and encourages everyone to look out for him- or herself. At the same time, the advent of the Internet has allowed people to connect with similar-minded people all over the world. As we channel energy into making new friends around the world we no longer need to care about our immediate neighbors. On a more positive note, with this reduction in top-down governing, there has been a corresponding shift away from the top-down mega-utopias dreamt up by an elite; today, we can strive for one million tiny utopias each dreamt up by a single person.

Fourth, the downgrading of dreams to hopes once it became clear that the dreams of the twentieth century were unsustainable, as the world's population has more than doubled in the last forty-five years to seven billion. The great modernist social dreams of the post-war era probably reached a peak in the 1970s when it started to become clear that the planet had limited

resources and we were using them up fast. As populations continued to grow at an exponential rate we would have to reconsider the consumer world set in motion during the 1950s. This feeling has become even more acute with the financial crash and the emergence since the new millennium of scientific data suggesting that the climate is warming up due to human activity. Now, a younger generation doesn't dream, it hopes; it hopes that we will survive, that there will be water for all, that we will be able to feed everyone, that we will not destroy ourselves.

But we are optimistic. Triggered by the financial crash of 2008, there has been a new wave of interest in thinking about alternatives to the current system. And although no new forms of capitalism have emerged yet, there is a growing desire for other ways of managing our economic lives and the relationship among state, market, citizen, and consumer. This dissatisfaction with existing models coupled with new forms of bottom-up democracy enhanced by social media make this a perfect time to revisit our social dreams and ideals and design's role in facilitating alternative visions rather than defining them. Of being a catalyst rather than a source of visions. It is impossible to continue with the methodology employed by the visionary designers of the 1960s and 1970s. We live in a very different world now but we can reconnect with that spirit and develop new methods appropriate for today's world and once again begin to dream.

But to do this, we need more pluralism in design, not of style but of ideology and values.

2.

A MAP OF UNREALITY

Once designers step away from industrial production and the marketplace we enter the realm of the unreal, the fictional, or what we prefer to think of as conceptual design—design about ideas. It has a short but rich history and it is a place where many interconnected and not very well understood forms of design happen—speculative design,[1] critical design,[2] design fiction,[3] design futures,[4] antidesign, radical design, interrogative design,[5] design for debate, adversarial design,[6] discursive design,[7] futurescaping,[8] and some design art.

For us, this separation from the marketplace creates a parallel design channel free from market pressures and available to explore ideas and issues. These could be new possibilities for design itself; new aesthetic possibilities for technology; social, cultural, and ethical implications for science and technology research; or large-scale social and political issues such as democracy, sustainability, and alternatives to our current model of capitalism. This potential to use the language of design to pose questions, provoke, and inspire is conceptual design's defining feature.

It is different from social and humanitarian design, and design thinking too, which, although also often rejecting market-driven design, still operate within the limits of reality as it is. This is very important for us. We are not talking about a space for experimenting with how things are now, making them better or different, but about other possibilities altogether.

We are more interested in designing for how things could be. Conceptual design provides a space for doing this. It deals, by definition, with unreality. Conceptual designs are not conceptual because they haven't yet been realized or are waiting to be realized but out of choice. They celebrate their unreality and take full advantage of being made from ideas. Patrick Stevenson Keating's *The Quantum Parallelograph* (2011) is a public engagement prop exploring ideas about quantum physics and multiverses by finding and printing out online information from a user's "parallel life." It uses abstraction along with generic technical references to suggest a strange technological device. It is clearly a prop but it sets to work on the imagination very quickly. The aesthetics are fresh, striking, and immediately signal that the object is conceptual without diminishing it in anyway. A more concrete example is *MTKS-3/The Meta-territorial Kitchen System-3* (2003) by Martí Guixé. It consists of models of components for an open source kitchen, the final objects are abstract, simplified geometric forms that celebrate their propness and make no effort at realism; they are what they are: ideas.

It is often said that if something is conceptual, it is only an idea, but that is missing the point. It is because it is an idea that it is important. New ideas are exactly what we need today. Conceptual designs are not only ideas but also ideals, and as the moral philosopher Susan Neiman has pointed out, we should measure reality against ideals, not the other way around: "Ideals are not measured by whether they conform to reality; reality is judged by whether it lives up to ideals. Reason's task is to deny that the claims of experience are final—and to push us to widen the horizon of our experience by providing ideas that experience ought to obey."[9]

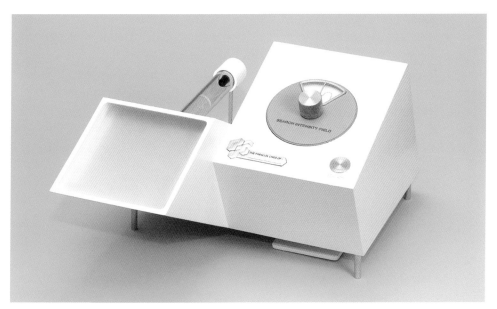

Patrick Stevenson-Keating, *The Quantum Parallelograph*, 2011.

Martí Guixé, *MTKS-3: The Meta-territorial Kitchen System-3*, 2003. Photograph by Imagekontainer/Inga Knölke.

One of the main purposes of conceptual design, therefore, as we see it, is to provide an alternative context to design that is driven entirely by market forces. It is a space for thinking, for trying out ideas, and ideals. As Hans Vaihinger writes in *The Philosophy of As If*, "The ideal is an ideational construct contradictory in itself and in contradiction with reality, but it has an irresistible power. The ideal is a practical fiction."[10]

A MAP OF UNREALITY

The spectrum of conceptual design is broad. Each area of design has its own form and is used in different ways. At one end it is very close to conceptual art and is about pure ideas, often to do with the medium itself. Much applied art, ceramics, furniture, and device art, for example, sit here. At the other end of the spectrum conceptual design means a parallel space of speculation that uses hypothetical or, more accurately, fictional products to explore possible technological futures.[11] Industrial and product design usually operate at this end. This is the end we are interested in.

Even though Marcel Duchamp is acknowledged as the first true conceptual artist, it was not until the 1960s that artists such as Sol LeWitt and Adrian Piper clearly articulated what it meant to make art out of ideas. In his "Sentences on Conceptual Art"[12] (1969) LeWitt lists what have become for many the core features of a conceptual artwork, for example:

> 10. Ideas can be works of art; they are in a chain of development that may eventually find some form. All ideas need not be made physical.

> 13. A work of art may be understood as a conductor from the artist's mind to the viewer's. But it may never reach the viewer, or it may never leave the artist's mind.

> 17. All ideas are art if they are concerned with art and fall within the conventions of art.

> 28. Once the idea of the piece is established in the artist's mind and the final form is decided, the process is carried out blindly. There are many side effects that the artist cannot imagine. These may be used as ideas for new works.

> 31. If an artist uses the same form in a group of works, and changes the material, one would assume the artist's concept involved the material.

One of the most interesting for us is point 9:

> The concept and idea are different. The former implies a general direction while the latter is the component. Ideas implement the concept.[13]

In design, people often struggle to get beyond the concept to appreciate and engage with the ideas. It is at the level of ideas that the craft of conceptual design happens. Ideas are constructed or found, evaluated, combined, edited, tweaked, and embedded.

Conceptual approaches exist in most areas of design, either in a pure state, usually for exhibitions, or fused with more commercial goals and available to buy. Graphic design has a long tradition of experimenting with ideas and an established critical context for discussing and debating them. The work of highly conceptual studios such as Åbäke, Metahaven, and Daniel Eatock is regularly discussed, exhibited, and debated in the design press. In *Facestate* (2011) Metahaven use the kind of strategic thinking usually applied to commercial corporate identity projects to critique the political implications of blurring boundaries between consumerism and citizenship, especially when social software is embraced by governments in the name of improved transparency and interaction.

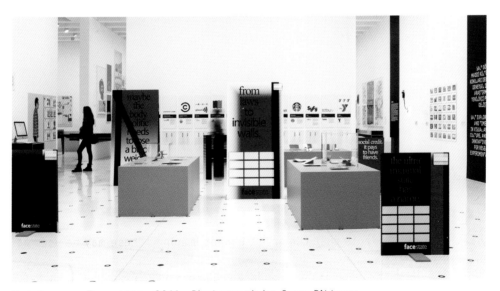

Metahaven, *Facestate*, 2011. Photograph by Gene Pittman.
Photograph courtesy of Walker Art Center.

In fashion it ranges from one-off haute couture pieces for the catwalk to mass-produced diffusion lines for sale in high street shops. In the 1960s, inspired by the space age, designers such as André Courrèges, Pierre Cardin, and Pacco Rabanne disregarded practicalities to explore ideas about the future using new forms, production processes, and materials. In the 1980s, Katherine Hamnett made protest t-shirts fashionable with her infamous slogan t-shirts such as "NUCLEAR BAN NOW," "PRESERVE THE RAINFORESTS," "SAVE THE WORLD," and "EDUCATION NOT MISSILES." Today, leading designers use the catwalk to present experimental clothes that more often communicate brand values and the designer's identity than challenge social norms. Hussein Chayalan is an exception. His shows are beautifully crafted vignettes that make use of ingenious objects and novel technologies; his "airplane dress" is one of our favorites. Companies such as Comme des Garçon, A-POC, and Martin Margiella make highly conceptual but wearable clothes that play with ideas of materiality and tailoring, social conventions and expectations, and aesthetics.

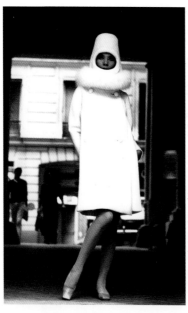

Pierre Cardin, *Space Age Collection*, 1966. Photograph courtesy of Archive Pierre Cardin.

Hussein Chalayan, *Before Minus Now*, 2000. Photograph by Chris Moore/Catwalking.

Droog by Peter van der Jagt, *Bottoms Up Doorbell*, 1994.
Photograph by Gerard Van Hees.

 Furniture design has a history of using chairs as vehicles for exploring new design philosophies and visions for everyday life, whether aesthetic, social, or political. The 1990s saw a renewed interest in conceptualism driven primarily by the Dutch design group Droog. It is hard to say when conceptualism first appeared in furniture design—definitely the Bauhaus's early bent steel tube chairs and in work by postwar Italian designers such as Bruno Munari, Ettore Sottsass, Studio De Pas D'Urbino, Lomazzi, Archizoom, Alessandro Mendini, and Memphis before design dissolved into a miasma of extreme commercialism in the 1980s. But, possibly, it was the designer William Morris who was the first to create critical design objects in the way we understand them today, that is, embodying ideals and values intentionally at odds with those of his own time.[14] As Will Bradley and Charles Esche point out in their introduction to *Art and Social Change*, William Morris's thinking is still relevant today through his opposition of utopian ideals of artistic production with capitalist industrialist models of production, which also influenced Walter Gropius and the Bauhaus.[15]

Today, although furniture is still where most conceptual activity happens, the focus is on aesthetics, manufacturing processes, and materials.[16] Designers such as Jurgen Bey and Martí Guixé go well beyond this, using conceptual design to explore social or political issues. Bey's *Slow Car* (2007), a motorized office chair and desk enclosure is designed to question our use of time spent in cars in highly congested cities. It is not intended to be mass produced but to circulate through exhibitions and publications.

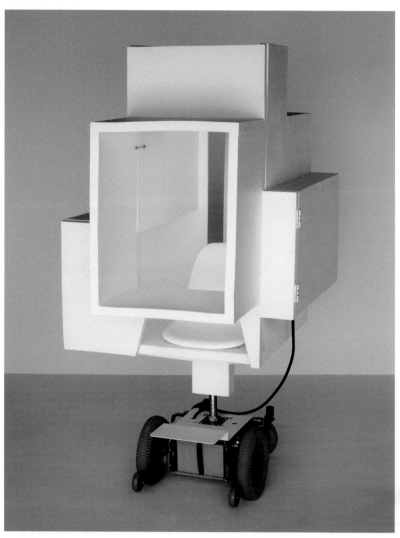

Studio Makkink and Bey/Vitra, *Slow Car*, 2007. Photograph by Studio Makkink and Bey. http://www.studiomakkinkbey.nl.

Martí Guixé's *Food Facility* (2005) for Mediamatic in Amsterdam was a prototype restaurant in the form of a performance space that used the Internet to outsource cooking. Customers gathered in the "restaurant," enjoying its social ambience but ordered their food from local take-away restaurants. The restaurant's kitchen was replaced by the kitchens of existing local take-aways. Customers were guided by food advisors, who provided information on food quality and estimated delivery time, and food DJs received deliveries and repackaged it for the food advisor to serve to the customer. The project experimented with the mixing of digital and analog cultures, using search engines to help reorganize traditional social events. Another project by Martí Guixé, *The Solar Kitchen Restaurant for Lapin Kulta* (2011), explores new ways of organizing a restaurant business around solar cooking technologies. Customers need to be flexible, forgiving, and adventurous; if it rains, for instance, lunch might be canceled or a cloudy sky might delay dinner.

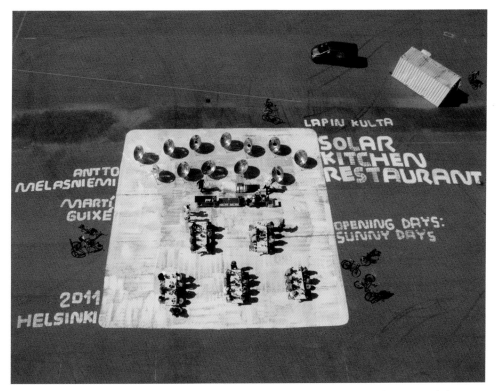

Martí Guixé, *Solar Kitchen Restaurant for Lapin Kulta*, 2011. Photograph by Imagekontainer/Inga Knölke.

There is even a well-established gallery system. Galerie Kreo in Paris works with designers including Ronan and Erwan Bouroullec, Konstantin Grcic, and Jasper Morrison as a lab for aesthetic experimentation and developing ideas that would be impossible in an industrial context. Grcic's *Champions* (2011) tables import craft techniques, aesthetics and graphics from the world of motor racing, and high-performance sports equipment into the world of furniture. Sometimes the ideas produced for these exhibitions can end up being developed elsewhere with industrial partners. The Bouroullec Brothers' *Algue* (2004), small plastic, organic-looking elements that can be linked together to form room dividers, began as an installation, only later becoming a highly successful product manufactured by Vitra and going on to sell in vast numbers.

Konstantin Grcic, *Apache*, detail, 2011, from the *Champions* series. Photograph courtesy of Galerie Kreo. © Fabrice Gousset.

Ronan and Erwan Bouroullec, *Algue*,
2004. © Tahon and Bouroullec.

Ronan and Erwan Bouroullec, *Algue*, 2004. Photograph by Andreas Sütterlin.
© Vitra.

Vehicle design, too, has a strong tradition of concept cars designed to be displayed in shows to communicate future design directions and gauge customer reaction. Roland Barthes's famous essay celebrating the Citroën DS in *Mythologies* captures the magic of these visions at their high point. Buckminster Fuller's 1930s prototype Dymaxion car promoted new ways of thinking about safety and aerodynamics. More recent studies have focused on style and imagery; Marc Newson's *021C* (1999) for Ford aimed to introduce new cultural references to car design, and Chris Bangle's *GINA* (2008) concept car for BMW suggested replacing current materials with futuristic shape-shifting materials that adjust the car's aerodynamics on the move. But, although technically innovative, concept cars rarely deal with the social and cultural implications of transportation systems and consistently focus on the car as an object. One recent exception, maybe not intentionally so, is Ora-ïto's *Evo Mobil* (2010) for Citroën, an imaginary evolution of early Citroëns such as the Traction Avant into a futuristic "personal mobility system," essentially a sedan chair—one of two designs intended to promote new thinking in the car industry about possible new directions and values.

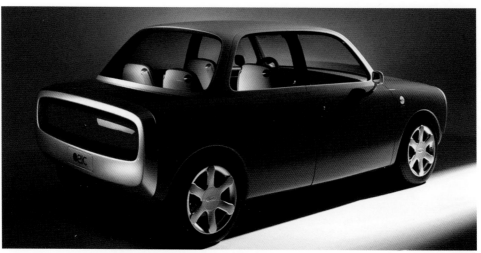

Marc Newson, *Ford 021C*, 1999. Photograph by Tom Vack. © 2012 Mark Newson Ltd.

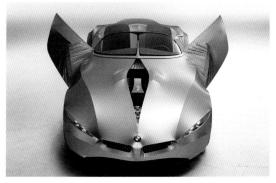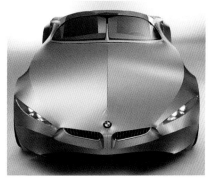

Chris Bangle, *BMW GINA*, 2008. © BMW AG.

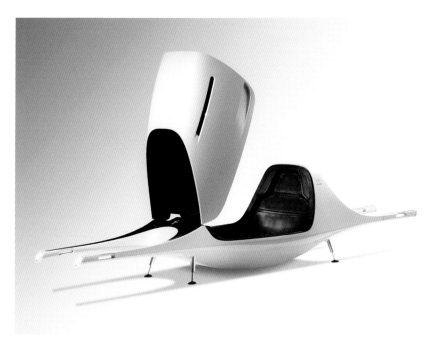

Ora Ito, *Concept Car*, 2010.

Of all the design disciplines it is probably architecture that has the richest, most diverse tradition for exploring ideas. From paper architecture to visionary design, its long history is full of exciting and inspiring examples. There is a tension between visionary architecture, which has an outward facing social or critical agenda, and paper architecture, which, though often introspective and concerned only with architectural theory, is rarely intended to ever be built. One of the most interesting examples to cross over

from idea to reality is Peter Eisenman's famous *House VI* (1975), which prioritized formalist concerns over practicalities to an extreme extent. The client later wrote about the many practical problems it had but still loved living in such a conceptual building.[17] The relationship between reality and unreality is particularly interesting in architecture because many buildings are designed to be built but remain on paper due to economic or political reasons. *House VI* is unusual because it was intentionally an uncompromising piece of architectural art someone could live in, just about. It was as though the owner lived inside an idea rather than a building.

Beyond this lies the world of film design and more recently game design, which deals less with conceptual objects and more with imaginary worlds. We will return to this subject later in chapter 5.

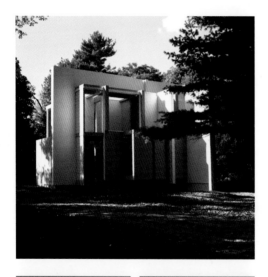

Peter Eisenman, *House VI*, east facade, 1975. Photograph by Dick Frank. Photograph courtesy of Eisenman Architects.

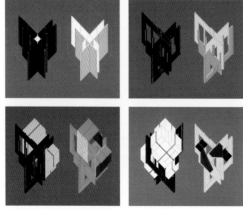

Peter Eisenman, *House VI*, 1975, axonometric drawings. Drawings courtesy of Eisenman Architects.

COMMODIFIED IMAGINATIONS

In the fields of applied arts, graphics, fashion, furniture, vehicle, and architecture, conceptual design is a highly valued, mature, and interesting way of working, and it embraces one-off experiments by individual designers through to products available in shops. Unlike these fields, product design struggles with this kind of work. At least at professional level, it is usually done by students, which although laudable means it can lack the depth and sophistication experienced designers would bring to it.

Although it is possible to buy a "conceptual" skirt from Comme des Garçons or A-POC, it is not possible to buy a conceptual phone, at least not since the failed but brave efforts of Enorme in the 1980s or Daniel Weil's batch-produced highly conceptual radios also from the 1980s. With the exception of farsighted entrepreneur designers such as Naoto Fukasawa and his +/-0 line of products, Maywa Denki's Otamatone, Sam Hecht/Industrial

Daniel Weil, *Radio in a Bag*, 1982.

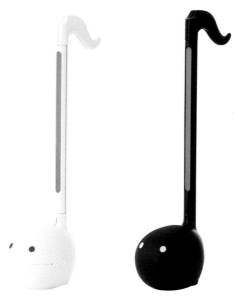

Maywa Denki, *Otamatone*, 2009.
© Yoshimoto Kogyo Co., Ltd., Maywa Denki and CUBE Co., Ltd.

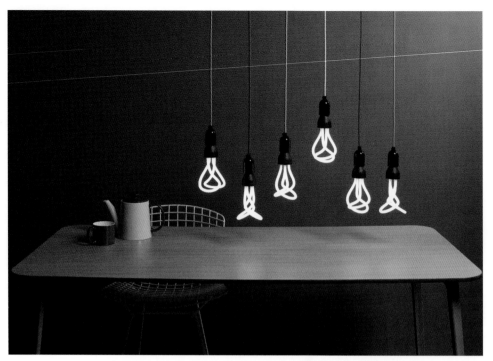

Hulger, *Plumen Light Bulb*, 2010. Photograph by Ian Nolan. Photography
© Ian Nolan.

Facility's everyday objects, and Hulger's low-energy Plumen Light Bulb,
product design remains closely aligned with market expectation and is one of
the few areas in which conceptual and commercial approaches really do
not mix.

 Does the difference in scales of production, technological complexity,
and need to address a mass market make work like this impossible in the
technology industry? Since the new millennium there has been a significant
increase in experimentation at the boundaries of interaction design and media
art sometimes referred to as device art[18] but it is usually focused on
aesthetic, communicative, and functional possibilities for new media rather
than visions for how life could be, and mainly takes the form of digital craft
rather than future speculations.[19] Artist-designer Ryota Kuwakubo is one of
the most established practitioners working in this way. Similar to many people
in the field of interactive devices his work sits between design and art. The
devices often look industrially produced but are usually one-offs for
galleries. His *Prepared Radios* (2006), programmed to filter out vowel sounds

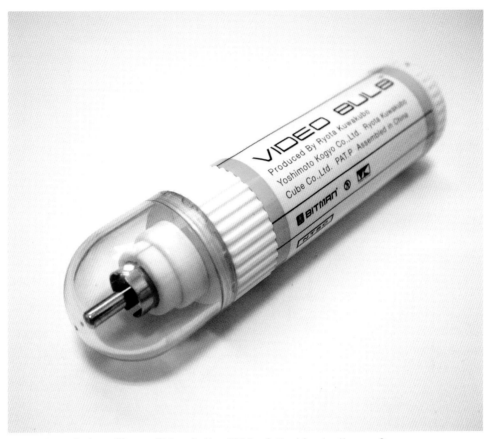

Ryota Kuwakubo, *Bitman Video Bulb*, 2005. © Yoshimoto Kogyo Co.,
Ltd., Maywa Denki and Ryota Kuwakubo.

from the broadcasts of local radio stations, are designed to look like
minimalistic domestic radios but are handmade. Some of his projects cross
over from one-offs to mass production, for example, his *Bitman Video Bulb*
(2005), which plugs into the back of a TV and plays a looped animation of his
Bitman character.

Philips Design Probes, *Microbial Home*, 2011. © Philips.

The technology industry does have its own tradition of conceptual design in the form of *Vision of the Future* video scenarios setting out future directions or promoting new corporate values but they are often very limited in their scope and vision. They usually feature perfect worlds for perfect people interacting perfectly with perfect technologies. Whirlpool, and especially Philips Design, are two companies that have consistently gone beyond this and successfully used conceptual projects to explore alternative visions for everyday life, which with Philips's design probes pushed the medium itself forward. Their *Microbial Home* (2011) is a proposal for integrating domestic activities such as cooking, energy usage, human waste management, food preparation, and storage, as well as lighting into one sustainable ecosystem in which each function's output is another's input. At the heart of the project is a view of the home as a biological machine.

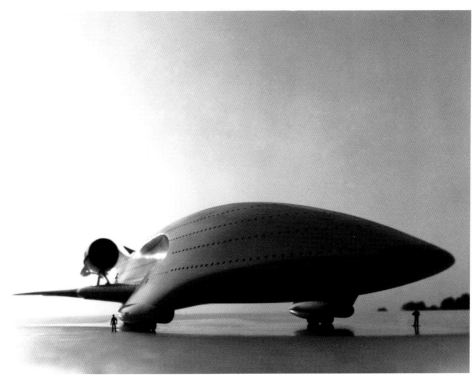

Luigi Colani, *Passenger Aircraft*, 1977. Photograph courtesy of Colani Trading AG.

Although not intended to be mass produced it is intended to have an impact on production by introducing new values and attitudes into how companies think about the home and its consumer products. Designers Syd Mead and Luigi Colani were pioneers of this form of speculative industrial design during the 1970s and 1980s. Colani's work for Canon cameras in the 1980s introduced a form of "biodynamic" design that continues to influence camera design today.

Since Syd Mead and Luigi Colani, there haven't really been many, if any, designers who have concentrated on developing highly speculative scenarios either independently or with companies. There have been occasional surrealistic moments from designers such as Marc Newson, Jaime Hayón, and Marcel Wanders, which although mainly marketing oriented, broke away from furniture to explore their imaginative inner worlds and fantastical design objects. Some of the most striking are Marc Newson's *Kelvin 40 Concept Jet* (2003) airplane, Marcel Wanders's oversized *Calvin Lamp* (2007), and his mosaic-tiled but fully functional car for the mosaic brand Bisazza. Wanders

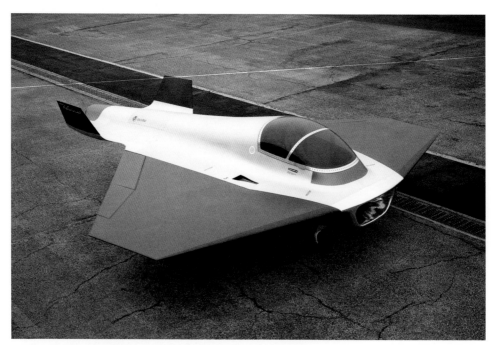

Mark Newson, *Kelvin 40 Concept Jet*, 2003. Fondation Cartier pour l'art Contemporain. Photograph by Daniel Adric. Photograph courtesy of Marc Newson Ltd.

claimed his oversized objects were a response to the democratization of design leaving designers with no choice but to draw from their own imagination to provide something special. These extravagantly absurd technological fantasy objects hinted at a future direction for design cut short by the global financial crash. Although decadent and often marketing exercises, for a moment, designers broke away from narrow cultural references and the limited imagination of most design shows.

Increasingly, design exhibitions are moving beyond showcasing designers and products to address more complex societal issues. The 2010 Saint Etienne International Design Biennale under the theme teleportation addressed a wide range of issues from alternative transportation to future technologies in nine interconnected exhibitions. *New Energy in Design and Art* (2011) at the Museum Boijmans Van Beuningen in Rotterdam presented alternative thinking by artists and designers around energy and MoMA's *Design and the Elastic Mind* (2008) explored interactions between design and science from the concrete to the highly speculative.

We recognize it is very difficult to finance this kind of design activity and there are limited opportunities but it is needed. It feeds the profession's imagination and it opens up new possibilities, not only for technology, materials, and manufacturing but also for narrative, meaning, and the rethinking of everyday life. Rather than waiting for commissions from industry or seeking out market gaps for new products, designers could work with curators and other professionals, independently of industry, in partnership with organizations focused on society in the broadest sense, not just business. Similar to architects, designers could take this on as a profession using some of our time for more civic purposes. This is also a role designers in academies could take on. Universities and art schools could become platforms for experimentation, speculation, and the reimagining of everyday life.

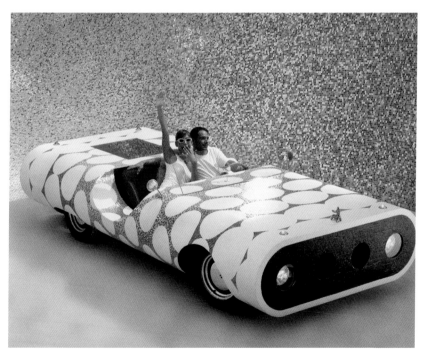

Marcel Wanders, *Antelope*, designed for Bisazza, 2004.
Photograph by Ottavio Tomasini. Photograph courtesy of
Fondazione Bisazza. http://www.fondazionebisazza.com.

3.
DESIGN AS CRITIQUE

To be human is to refuse to accept the given as given.[1]

Once we accept that conceptual design is more than a style option, corporate propaganda, or designer self-promotion, what uses can it take on? There are many possibilities—socially engaged design for raising awareness; satire and critique; inspiration, reflection, highbrow entertainment; aesthetic explorations; speculation about possible futures; and as a catalyst for change.

For us, one of the most interesting uses for conceptual design is as a form of critique. Maybe it is because of our background in design but we feel that the privileged space of conceptual design should serve a purpose. It is not enough that it simply exists and can be used to experiment or entertain; we also want it to be useful, to have a sort of social usefulness, specifically, to question, critique, and challenge the way technologies enter our lives and the limitations they place on people through their narrow definition of what it means to be human, or as Andrew Feenberg writes, "The most important question to ask about modern societies is therefore what understanding of human life is embodied in the prevailing technical arrangements."[2]

CRITICAL DESIGN

We coined the term *critical design* in the mid-nineties when we were researchers in the Computer Related Design Research Studio at the Royal College of Art. It grew out of our concerns with the uncritical drive behind technological progress, when technology is always assumed to be good and capable of solving any problem. Our definition then was that "critical design uses speculative design proposals to challenge narrow assumptions, preconceptions, and givens about the role products play in everyday life."

It was more of an attitude than anything else, a position rather than a methodology. Its opposite is affirmative design: design that reinforces the status quo.

For many years the term slipped into the background but recently it has resurfaced as a part of growing discourse in design research,[3] exhibitions,[4] and even articles in the mainstream press.[5] This is good but the danger is it becomes a design label rather than an activity, a style rather than an approach.

There are many people using design as a form of critique who have never heard of the term *critical design* and who have their own way of describing what they do. Naming it *critical design* was simply a useful way of making this activity more visible and subject to discussion and debate. And, although it is very exciting to see it taken up by so many people and evolving in new directions,[6] over the years its meaning and potential has changed for us, too, and we feel it is the right moment to offer an updated view of what we think it is.

CRITIQUE/CRITICAL THINKING/CRITICAL THEORY/CRITICISM

Critique is not necessarily negative; it can also be a gentle refusal, a turning away from what exists, a longing, wishful thinking, a desire, and even a

dream. Critical designs are testimonials to what could be, but at the same time, they offer alternatives that highlight weaknesses within existing normality.

When people encounter the term *critical design* for the first time, they often assume it has something to do with critical theory and the Frankfurt School or just plain criticism. But it is neither. We are more interested in critical thinking, that is, not taking things for granted, being skeptical, and always questioning what is given. All good design is critical. Designers start by identifying shortcomings in the thing they are redesigning and offer a better version. Critical design applies this to larger more complex issues. Critical design is critical thought translated into materiality. It is about thinking through design rather than through words and using the language and structure of design to engage people. It is an expression or manifestation of our skeptical fascination with technology, a way of unpicking the different hopes, fears, promises, delusions, and nightmares of technological development and change, especially how scientific discoveries move from the laboratory into everyday life through the marketplace. The subject can vary. On the most basic level it is about questioning underlying assumptions in design itself, on the next level it is directed at the technology industry and its market-driven limitations, and beyond that, general social theory, politics, and ideology.

Some people take it very literally as negative design, anti-everything, interested only in pointing out shortcomings and limitations, which if already understood and appreciated, we agree is a pointless activity. This is where critical design gets confused with commentary. All good critical design offers an alternative to how things are. It is the gap between reality as we know it and the different idea of reality referred to in the critical design proposal that creates the space for discussion. It depends on dialectical opposition between fiction and reality to have an effect. Critical design uses commentary but it is only one layer of many. Ultimately it is positive and idealistic because we believe that change is possible, that things can be better; it is just that the way of getting there is different; it is an intellectual journey based on challenging and changing values, ideas, and beliefs. In *Do You Want to Replace the Existing Normal?*, a project we did with designer Michael Anastassiades in 2007-2008, we designed a collection of electronic products that intentionally embodied values at odds with those we would expect from products today. The statistical clock searches newsfeeds for fatalities and organizes them by form of transport in a database. The owner sets the channel to *car, train, plane,* for instance, and once the

device detects an event, it speaks out the numbers in sequence, one, two, three. . . . We imagined a world where there was a desire for products that met existential needs, reminding us of the frailty of life. Although fully functional and technically simple, we knew there was no market for a product like this because people do not want to be reminded of such things. But, that is its point: to confront us with alternative needs and hint at a parallel world of everyday philosophical products. These objects are designed in anticipation of that time. What would have to change for a need like this to emerge?

Dunne & Raby and Michael Anastassiades, *The Statistical Clock*, 2007-2008. Photograph by Francis Ware. Photograph courtesy of Francis Ware.

But it is not just about design. In fact, the power of design is often overestimated. Sometimes we can have more effect as citizens than as designers. Protests and boycotts can still be the most effective ways of making a point.[7] We have recently become interested in the idea of critical shopping. It is by buying things that they become real, moving from the virtual space of research and development by way of advertising into our lives. We get the reality we pay for. It is in the shops, waiting to happen, waiting to be consumed. Critical shoppers, by being more discriminating, could prevent certain material realities taking shape and encourage others to flourish. Manufacturers are never sure which reality we will embrace or reject, they simply offer them up and do their best through advertising to influence our choices.

Once workers could exert power by withholding their labor, by striking; today, as we see again and again, this is less so. In today's economy it is as consumers that we have power. The most threatening act of protest for a capitalist system would be for its citizens to refuse to consume. As Erik Olin Wright points out, "If somehow it were to come to pass that large numbers of people in a capitalist society were able to resist the preferences shaped by consumerist culture and opt for 'voluntary simplicity' with lower consumption and much more leisure time, this would precipitate a severe economic crisis, for if demand in the market were to significantly decline, the profits of many capitalist firms would collapse."[8]

As we can see from the current economic crisis: "The state's role in promoting the consumption bias inherent in capitalist economies is particularly sharply revealed in times of economic crisis. In an economic downturn, governments attempt to 'stimulate' the economy by, in various ways, encouraging people to consume more by reducing taxes, by reducing interest rates so borrowing is cheaper or, in some cases, by directly giving people more money to spend."[9]

In a consumer society like ours, it is through buying goods that reality takes shape. The moment money is exchanged, a possible future becomes real. If it did not sell it would be sent back, becoming a rejected reality. In a consumer society, the moment we part with our money is the moment a little bit of reality is created. Not just physical reality or cultural but psychological, ethical, and behavioral. This is one of the purposes of critical design—to help us become more discerning consumers, to encourage people to demand more from industry and society as critical consumers. The designer is not positioned on a higher moral plane, a common criticism of critical theory,

but like everyone else is immersed in the system. Design can help raise awareness of the consequences of our actions as citizen-consumers.

DARK DESIGN: THE POSITIVE USE OF NEGATIVITY

One of critical design's roles is to question the limited range of emotional and psychological experiences offered through designed products. Design is assumed only to make things nice; it is as if all designers have taken an unspoken Hippocratic oath to never make anything ugly or think a negative thought. This limits and prevents designers from fully engaging with and designing for the complexities of human nature, which of course is not always nice.

Critical design can often be dark or deal with dark themes but not just for the sake of it. Dark, complex emotions are usually ignored in design; nearly every other area of culture accepts that people are complicated, contradictory, and even neurotic, but not design. We view people as obedient and predictable users and consumers. Darkness as an antidote to naive techno-utopianism can jolt people into action. In design, darkness creates a frisson that excites and challenges. It is more about the positive use of negativity, not negativity for its own sake but to draw attention to a scary possibility in the form of a cautionary tale. A good example of this is Bernd Hopfengaertner's *Belief Systems* (2009). Hopfengaertner asks what would happen if one of the tech industry's many dreams comes true, if all the research being done by separate companies into making humans machine readable were to combine and move from laboratory to everyday life: combined algorithms and camera systems that can read emotions from faces, gait, and demeanor; neurotechnologies that cannot exactly read minds but can make a good guess at what people are thinking; profiling software that tracks and traces our every click and purchase; and so on. He developed six scenarios that explored different aspects of this rather grim world. In one, a person wants to buy a teapot. She walks up to a machine, pays, then hundreds of images of teapots flash before her on a screen suddenly stopping on one, the one the machine decides the shopper wants from reading micro expressions on her face. In another, a person is trying to identify muscle groups in her face so she can learn to control them and not give her feelings away, voluntarily becoming inhuman in order to protect her humanity. For some this is the ultimate user-centered dream, but for many Hopfengaertner's project is a cautionary tale fast-forwarding to a time when currently diverse technologies are combined to ease our every interaction with technology.

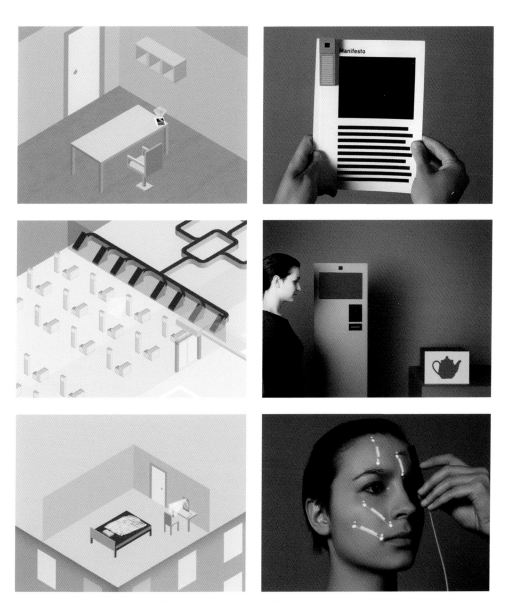

Bernd Hopfengaertner, *Belief Systems*, 2009.

Humor is a very important but often misused element in this kind of design. Satire is the goal but often only parody and pastiche are achieved. These reduce the effectiveness of the design in a number of ways. Borrowing from existing formats, they signal too clearly that it is ironic and so relieve some burden from the viewer. The viewer should experience a dilemma: is it serious or not? Real or not? For a critical design to be successful viewers need to make up their own mind. It would be very easy to preach: a skillful use of satire and irony can engage the audience in a more constructive way by appealing to the imagination as well as engaging the intellect. Deadpan and black humor work best[10] but a certain amount of absurdity is useful, too. It helps resist streamlined thinking and instrumental logic that leads to passive acceptance; it is disruptive and appeals to the imagination.

Good political comedians do this well. Probably the most celebrated artists working in this way are The Yes Men (Jacques Servin and Igor Vamos) who use satire, shock tactics, caricature, hoaxes, fakery, spoofing, absurdity, and "identity correction" (impersonating target organizations and individuals) to raise awareness of the mistreatment of ordinary people by large corporations and governments. Posing as representatives of target organizations they use corporate and governmental tactics such as spin to make outlandish claims or present fictional scenarios that are enthusiastically picked up by the popular media. Although impressive and highly entertaining, for us it is too sensational and fits in a context of media activism, performance, and theater. Their fake *4 July 2009 New York Times* is different, though; it is subtle, beautifully crafted, and through headlines such as "Iraq War Ends" and "Nation Sets Its Sights on Building Sane Economy" showed what a different, better world might be like. Approximately eighty thousand copies were handed out in several cities around the United States.

Unfortunately, in critical design, irony can all too often be interpreted as cynicism especially in a discipline in which people expect solutions, functionality, and realism. As viewers, when we encounter critical designs we need to accept that appearances can be deceptive and similar to other cultural products; they require effort from the viewer. We explored this in the huggable atomic mushrooms part of a collection of products we designed with Michael Anastassiades in 2004-2005 called *Designs for Fragile Personalities in Anxious Times*. Each atomic mushroom was based on a nuclear test and available in small, medium, or large sizes. We were inspired by treatments for phobias in which patients are exposed to the source of their fear in increasing doses. In the case of our mushrooms, someone with a dread of nuclear

The New York Times

Special Edition

Today, clouds part, more sunshine, recent gloom passes. Tonight, strong leftward winds. Tomorrow, a new day. Weather map throughout.

VOL. CLVIV . . No. 54,631 NEW YORK, SATURDAY, JULY 4, 2009 FREE

Nation Sets Its Sights on Building Sane Economy

True Cost Tax, Salary Caps, Trust-Busting Top List

By T. VEBLEN

The President has called for swift passage of the Safeguards for a New Economy (S.A.N.E.) bill. The omnibus economic package includes a federal maximum wage, mandatory "True Cost Accounting," a phased withdrawal from complex financial instruments, and other measures intended to improve life for ordinary Americans. (See highlights box on Page A10.) He also repeated earlier calls for passage of the "Ban on Lobbying" bill currently making its way through Congress.

Treasury Secretary Paul Krugman stressed the importance of the bill. "Markets make great servants, terrible leaders, and absurd religions," said Krugman, quoting Paul Hawken, an advocate of corporate responsibility and author of "Blessed Unrest, How the Largest Movement in the World Came into Being and Why No One Saw It Coming."

"At this point, the market is our leader and our religion. No wonder the median standard of living has been declining so much for so long."

Krugman said that the new Treasury bill seeks to ensure the prosperity of all citizens, rather than simply supporting large corporations and the wealthy. "The market is supposed to serve us. Unfortunately, we have ended up serving the market. That's very bad."

Much as Roosevelt, after the Great Depression, put the brakes on C.E.O. wages and irresponsible banking practices, administration officials claim that today we need to rein in the industry that has caused such chaos and misery.

"The building blocks of post-World War II American middle-class prosperity have all been swept away," said House Speaker Nancy Pelosi, who initially op-

Continued on Page A10

IRAQ WAR ENDS

COURTESY ARMY.MIL

U.S. Army helicopters begin moving troops and equipment from Saddam Hussein's former Baghdad palace.

Troops to Return Immediately

By JUDE SHINBIN

WASHINGTON — Operation Iraqi Freedom and Operation Enduring Freedom were brought to an unceremonious close today with a quiet announcement by the Department of Defense that troops would be home within weeks.

"This is the best face we can put on the most unfortunate adventure in modern American history," Defense spokesman Kevin Sites said at a special joint session of Congress. "Today, we can finally enjoy peace — not the peace of the brave, perhaps, but at least peace."

As U.S. and coalition troops withdraw from Iraq and Afghanistan, the United Nations will move in to perform peacekeeping duties and aid in rebuilding. The U.N. will be responsible for keeping the two countries stable; coordinating the rebuilding of hospitals, schools, highways, and other infrastructure; and overseeing upcoming elections.

The Department of the Treasury confirmed that all U.N. dues owed by the U.S. were paid as of this morning, and that moneys previously earmarked for the war would be sent directly to the U.N.'s Iraq Oversight Body.

The president noted that the Iraq War had resulted in the burning of many bridges. "Yet our history with our allies runs deep," he said, "and we all know that friends forgive friends for anything. Or nearly." A spokesperson for the French Ministry of Defense confirmed that France would assist the U.S. withdrawal. "The U.S. helped the Soviet Union defeat Hitler. We do recognize that."

In conflict zones worldwide, leaders and rebels pledged peace. (See "In Conflict Zones Worldwide, Peace Moves," on Page A4.)

On Wall Street, reactions were mixed, with the Dow Jones Industrial Average up 84 points, to close at 4,212. While KBR stock was quickly downgraded to a "junk" rating of BBB-, defense contractors such as Lockheed Martin and Northrop Grumman started up.

Continued on Page A5

Maximum Wage Law Succeeds

Salary Caps Will Help Stabilize Economy

By J.K. MALONE

WASHINGTON — After long and often bitter debate, Congress has passed legislation, fiercely fought for by labor and progressive groups, that will limit top salaries to fifteen times the minimum wage. Tying the bill to a plan of overall reform of the U.S. economy, the bill echoes a similar effort enacted by President Franklin Roosevelt in 1942, which was followed by the longest period of growth for the middle class in U.S. history.

"When C.E.O. salaries remain stable thanks to high taxation of high salaries, there's little incentive to take big risks with shareholders' money, and the economy remains in a steady growth mode," said Senator Barney Frank, one of the bill's co-sponsors. "But when C.E.O. salaries can fly through the roof, there's a very strong incentive for C.E.O.s

Continued on Page A10

TREASURY ANNOUNCES "TRUE COST" TAX PLAN

By MARCUS S. DRIGGS

The long-awaited "True Cost" plan, which requires product prices to reflect their cost to society, has been signed into law.

Beginning next month, throwaway items like plastic water bottles and other items which are wasteful or damaging to the environment will be heavily taxed, as in many developed countries. Steep taxes will also apply to large cars and gasoline.

The new plan calls for a 200 percent tax on gasoline, comparable to the one long in effect in most European countries. Companies and consumers are already switching in droves from inefficient gas vehicles to new electric cars. "We suddenly have a waiting list 200 names long for the EV1," said Jake Cluber, the owner of Cluber Chevrolet in

Continued on Page A10

Recruiters Train for New Life

As a ban is imposed on recruiting minors, ex-recruiters nationwide look for new work. The Times follows one on his job-hunt odyssey through Manhattan and surrounding areas.

BY BARRY GLOAD, PAGE A12

Last to Die

Two proportional monuments — one to the Iraqi dead, 300 feet high, and one to the American dead, 15 feet high — are unveiled in Baghdad, and a five-year-old boy whose lifespan coincided with that of the Iraq War is remembered.

BY J. FINISTERRA, PAGE A5

USA Patriot Act Repealed

Eight years later, a shamefaced Congress quietly repeals the much-maligned USA Patriot Act, unanimously… or almost.

BY SYBIL LUDDINGTON, PAGE A8

Evangelicals Open Homes to Refugees

Up to a million Iraqi exiles — nearly half of the total — will find sanctuary in Christian homes across the U.S., vows the National Association of Evangelicals. Other denominations are expected to follow.

BY W. WILBERFORCE, PAGE A7

Public Relations Industry Starts to Shut Down

The public relations industry has been criticized for misleading the American people, corrupting politicians, and even helping to start wars. Now, it's beginning the process of shutting down for good.

BY LOUIS BECK, PAGE A10

Ex-Secretary Apologizes for W.M.D. Scare

300,000 Troops Never Faced Risk of Instant Obliteration

By FRANK LARIMORE

Ex-Secretary of State Condoleezza Rice reassured soldiers that the Bush Administration had known well before the invasion that Saddam Hussein lacked weapons of mass destruction.

"Now that all of you brave servicemen and women are returning, it's important to us to reassure you, and the American people, that we were certain Hussein had no W.M.D.s and that he would never launch a first strike against the U.S.," Ms. Rice told a group of wounded soldiers at a Veterans' Administration hospital yesterday.

"I want you to know that if we

Yes Men, *4 July 2009 New York Times*, 2009.

annihilation would begin with *Priscilla (37 Kilotons, Nevada 1957)*, the smallest huggable atomic mushroom in the series. The objects were created in a dry and straightforward way with the high attention to quality of materials, construction, and detail one would expect in a well-designed object. It is through its demeanor that one starts to wonder just how serious it is. Due to its softness it slumps, giving it a slightly pathetic look that, when you remember what it represents, begins to create conflicting emotions in the viewer.

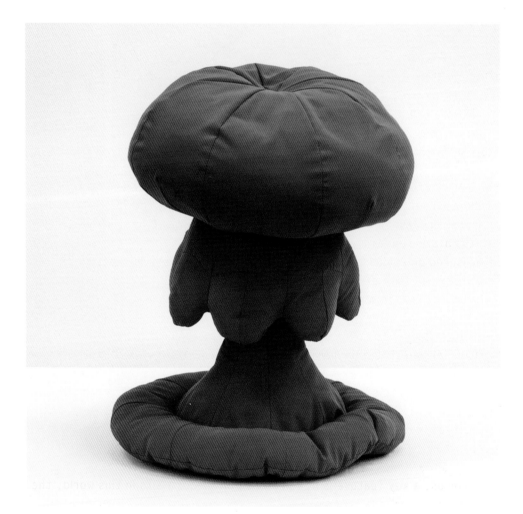

Dunne & Raby and Michael Anastassiades, *Huggable Atomic Mushrooms: Priscilla (37 Kilotons, Nevada 1957)*, 2007-2008. Photograph by Francis Ware. Photograph courtesy of Francis Ware.

Dark design is not pessimistic, cynical, or misanthropic; it is a counterpoint to a form of design that through denial does more harm than good. Dark design is driven by idealism and optimism, by a belief that it is possible to think our way out of a mess and that design can play an active role. Negativity, cautionary tales, and satire can jolt the viewer out of a cozy complacency that all is well. It aims to trigger shifts in perspective and understanding that open spaces for as-of-yet, unthought-of possibilities.

CRITIQUING CRITIQUE

Without an intellectual framework it is very difficult to advance the practice of critical design; lots of projects happen but many simply repeat what has gone before. We need some criteria that make it possible to advance this form of design through reflection and critique or at least get a sense of how the area can be refined. Conventional design's success is measured against how well it sells and how elegantly conflicts among aesthetics, production, usability, and costs are resolved. How is critical design's success measured?

Design as critique can do many things—pose questions, encourage thought, expose assumptions, provoke action, spark debate, raise awareness, offer new perspectives, and inspire. And even to entertain in an intellectual sort of way. But what is excellence in critical design? Is it subtlety, originality of topic, the handling of a question? Or something more functional such as its impact or its power to make people think? Should it even be measured or evaluated? It's not a science after all and does not claim to be the best or most effective way of raising issues.

Critical design might borrow heavily from art's methods and approaches but that is it. We expect art to be shocking and extreme. Critical design needs to be closer to the everyday; that's where its power to disturb lies. A critical design should be demanding, challenging, and if it is going to raise awareness, do so for issues that are not already well known. Safe ideas will not linger in people's minds or challenge prevailing views but if it is too weird, it will be dismissed as art, and if too normal, it will be effortlessly assimilated. If it is labeled as art it is easier to deal with but if it remains design, it is more disturbing; it suggests that the everyday life as we know it could be different, that things could change.

For us, a key feature is how well it simultaneously sits in this world, the here-and-now, while belonging to another yet-to-exist one. It proposes an alternative that through its lack of fit with this world offers a critique by asking, "why not?" If it sits too comfortably in one or the other it fails. That is why for us, critical designs need to be made physical. Their physical

presence can locate them in our world whereas their meaning, embodied values, beliefs, ethics, dreams, hopes, and fears belong somewhere else. This is where the critique of critical design should focus, on crafting its coexistence in the here-and-now and yet-to-exist, and when done successfully, providing what author Martin Amis has called "complicated pleasure."

COMPASSES NOT MAPS

Using design as a form of critique is just one use for design, as is communication or problem solving. We believe that some design should always question prevailing values and their underlying assumptions and that this activity can sit beside mainstream design rather than replace it. The challenge is to keep evolving techniques that are appropriate to the times and identifying topics that need to be highlighted, reflected on, or challenged.

In *Envisioning Real Utopias*, Erik Olin Wright describes emancipatory social science "as a theory of a journey from the present to a possible future: the diagnosis and critique of society tells us why we want to leave the world in which we live; the theory of alternatives tells us where we want to go; and the theory of transformation tells us how to get from here to there—how to make viable alternatives achievable."[11]

For us, the fulfillment of this journey is highly unlikely if is set out like a blueprint. Instead, we believe to achieve change, it is necessary to unlock people's imaginations and apply it to all areas of life at a microscale. Critical design, by generating alternatives, can help people construct compasses rather than maps for navigating new sets of values.

Much energy is going into developing ways of extending life but very little consideration is being given to its social and economic implications. In *When We Live to 150* (2012) Jaemin Paik asks, "how would family life change if we all lived to one-hundred and fifty or beyond?" With up to six generations living together and the possibility of huge age gaps between siblings, the traditional model of the family would change dramatically, perhaps even becoming financially unsustainable due to the burden of its large membership. Her project explores the lives and structures of future families in an era of extended life spans by tracing the story of seventy-five year-old Moyra and her sprawling contract-based family. Like the flat-share system, it would be possible to have a family-share in which people move from family to family taking on different roles to suit their changing needs as their long lives unfold. Moyra decides to renew her thirty-year marriage contract with Ted, ensuring they receive better social support and tax benefits from the state.

Aged eighty-two, Moyra's second thirty-year marriage contract with Ted expires. She decides to leave Ted and move to a "two-generation" family where she joins a new husband and a fifty-two-year-old "child." Presented through a mockumentary and photographic vignettes the project does not offer a design solution or map but serves as a tool for thinking through our own beliefs, values, and priorities when it comes to the pros and cons of extreme life extension.

Jaemin Paik, *When We All Live to 150*, 2012.

By acting on peoples' imaginations rather than the material world, critical design aims to challenge how people think about everyday life. In doing this, it strives to keep alive other possibilities by providing a counterpoint to the world around us and encouraging us to see that everyday life could be different.

4.
CONSUMING MONSTERS:
BIG, PERFECT, INFECTIOUS

> While we are more than ever aware of both the promise and the threat
> of technological advance, we still lack the intellectual means and the
> political tools for managing progress.[1]

One area in which design as critique has obvious practical applications is
science research. By moving upstream and exploring ideas before they become
products or even technologies, designers can look into the possible
consequences of technological applications before they happen. We can use
speculative designs to debate potential ethical, cultural, social, and political
implications.

LIVING IN EXTREME TIMES

A weird and wonderful world is taking shape around us.[2] Genetics, nanotechnology, synthetic biology, and neuroscience are all challenging our understanding of nature and suggesting new design possibilities at a level and scale never before possible. If we take just one area, biotechnology, and look more closely, we can see that a revolution is well underway. It is no longer about designing the things in the environment around us but designing life itself from microorganisms to humans, yet as designers we devote very little time to reflecting on what this means.

Driven by breakthroughs in genetics, animals are cloned and genetically modified to improve their food potential, human babies are designed to order and bred to provide organs and tissue for their siblings, fish and knock-out pigs are made to glow in the dark, and transgenic goats are engineered to produce military grade spider silk for use in bulletproof vests.[3] Chimera with comical names like geep and zorse and cows that produce humanlike milk have been created. Meat is grown in labs from animal cells, an artist has developed bulletproof skin, and a scientist has claimed to have created the first synthetic life form.[4] Being able to design life, both human and animal, is at the core of many of these developments. They have huge consequences for what it means to be human, how we relate to each other, our identity, our dreams, hopes, and fears. Of course we have always been able to design nature through selective plant and animal breeding but the difference now is the speed at which these changes will manifest themselves and the extreme nature of the changes.

LAB > MARKET > EVERYDAY LIFE

Many of these ideas exist as one-off genetic experiments in laboratories but as microbiologists and engineers begin to work together on the industrialization and systematization of genetic engineering, especially in synthetic biology, these ideas will move from the laboratory into everyday life through the marketplace. Procedures that are currently highly regulated and accessed only through health care may become freely available in a market shaped by consumer desire rather than therapeutic need. Are we prepared to treat society as a living laboratory as we do with digital technologies? Yes, Facebook affects our behavior and social relations but we can choose not to use it. Once we begin to design or redesign life itself, it gets complicated; the consequences are more profound and the very nature of being human could change.

We need to question these ideas (and ideals) and explore their human consequences once applied on a mass scale to our daily lives. This is where design enters; we can take research happening in laboratories and fast-forward to explore possible applications driven by human desire rather than therapeutic need. By facilitating debate on the implications of advanced research in science, design can take on a practical, almost social purpose, and in doing so, play a role in the democratization of technological change by widening participation in debates about future technologies.

To do this we need to move design upstream, beyond product, beyond technology, to the concept or research stage, and to develop speculative designs, or "useful fictions," for facilitating debate. As designers, we need to shift from designing applications to designing implications by creating imaginary products and services that situate these new developments within everyday material culture. As the science fiction writer Frederick Pohl once remarked, a good writer does not think up only the automobile but also the traffic jam. Just as ergonomics emerged during the mechanical age to ensure a better physical fit between our bodies and machines, and user-friendliness came about during the computer age to ensure a better fit between our minds and computers, ethics needs to be at the forefront of working with biological technologies. We need to zoom out and consider what it means to be human and how to manage our changing relationship to nature and our new powers over life. This shift in focus requires new design methods, roles, and contexts.

CONSUMER-CITIZENS

In much of the debate so far, the public have participated as citizens arguing in very general terms about the ethical, moral, and social issues. Yet, when we act as consumers we often suspend these general beliefs and act on other impulses. There is a separation between what we believe ought to be and how we actually behave when we want to use a biotech service or product. Usually when we discuss big issues we do so as citizens, yet it is as consumers that we help reality take shape. It is only when products are bought that they enter everyday life and have an effect. The act of buying determines our technological future. By presenting people with fictional products, services, and systems from alternative futures people can engage critically with them as citizen-consumers. Being faced with a complex mix of contradictory emotions and responses opens up new perspectives on the debate about biotechnology.

An example of this is *Carnivorous Domestic Entertainment Robots* (2009) by designers James Auger and Jimmy Loizeau. They are designed to look like contemporary domestic furniture rather than appliances or machines. Auger

and Loizeau looked at research being done into microbial fuel cells that would allow robots to exist autonomously in the wild by converting organic matter like insects into energy, and they wondered how this might translate into new types of domestic robot. Each of the five robots dramatizes the process of creating energy from rodents or insects. The "flypaper robotic clock," for instance, uses a loop of flypaper rotated by a small motor from which flies and other insects are scraped into a microbial fuel cell. The energy generated by the flies is used to power the motor and a small LCD clock. The project was extremely successful in generating debate online, in the press and even on TV about the implications of using microbial fuel cells to power domestic robots.

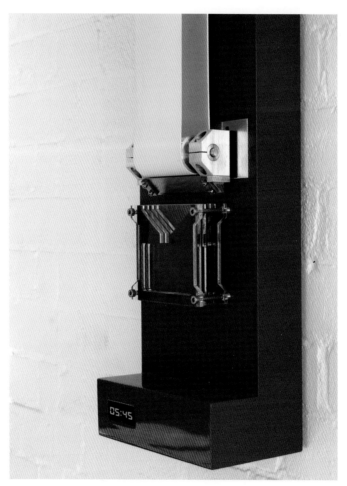

Auger-Loizeau, *Flypaper Robotic Clock*, 2009, from the series *Carnivorous Domestic Entertainment Robots*.

SUBVERTING DESIGN LANGUAGE

Design can shift the discussion from one of abstract generalities separated from our lives to tangible examples grounded in our experiences as members of a consumer society. Not to trivialize issues but because, for the most part, we live in a consumer society and consumerism drives economic growth in most Western societies. In this way, people can become involved in the debate earlier creating a dialogue between the public and the experts who define the policies and regulations that will shape the future of biotechnology. In other words, design can explore public perceptions of different biofutures before they happen and potentially make a contribution to the design of regulations that ensure the most humane and desirable futures are the most likely to become reality.

Speculating through design by presenting abstract issues as fictional products enables us to explore ethical and social issues within the context of everyday life. We can look at how different ways of purchasing biotech services (through a family doctor or on the Internet, for instance) or how different providers of a service affect people's perceptions of biotechnology. Ideas of right and wrong are not just abstractions but are entangled in everyday consumer choices. The idea is not to show how things will be but to open up a space for discussion so that people can form their own opinion about what kind of biofuture they desire.

There are some concerns with this approach though. Dangerous ideas can be conceived that open up possibilities better left unexplored, and once thought cannot be unthought. And these projects might prepare people for what is to come by unintentionally paving the way for a greater acceptance of biotechnology through desensitization. Despite this, however, we feel the benefits of this approach far outweigh the negatives.

DESIGN + SCIENCE

Design is relatively new to this area but art-science crossovers have happened for decades.[5] In the United Kingdom it even has its own category, SciArt. SciArt is sometimes criticized as bad science and bad art, and it can be, but more often it is simply something different, not science and not art.

Much SciArt takes on the function of celebrating, promoting, and communicating science, usually through aesthetically sophisticated science-related imagery, processes, or products. It sits within a tradition of using art to aid the public understanding of science, which recently has shifted to public engagement with science through workshops, platforms, and open processes.[6] Design, too, has made a contribution to this area in the form of

exhibits, experiences, and environments found in expos and science museums. Charles and Ray Eames's *Mathematica: A World of Numbers . . . and Beyond* (1961) for IBM's contribution to the California Museum of Science and Industry was one of the first. More recently, many specialist design companies have emerged to work with science museums around the world to develop highly sophisticated interactive exhibits. Although all this has a place and value, it is not what we are interested in. We believe that design can go beyond this communicative role and facilitate debate and reflection about the social, cultural, and ethical implications of science.

For many funding organizations, and even artists and scientists, the ideal model for art and science is the collaborative project in which an artist and scientist work together to develop a new piece of work. This is an almost utopian dream of art-science collaboration, but in our view, one or the other is usually driving the project. Either the artist is helping the scientist communicate his or her research or the scientist is technically assisting or advising the artist. Related to this is the idea of artist residencies in the research labs of high-tech companies where artists are given free rein to respond to and use work happening around them. On the most basic level it helps to promote the work of the lab and bring it to a wider audience but its true purpose is to spark innovation through the fresh perspective a technologically naive artist might bring to ongoing research. Although Experiments in Art and Technology (EAT)'s 1960s experimental program was one of the first to place artists in industry, it is Xerox PARC that is the best known for this model, especially during the 1970s and early 1980s.

One of the more interesting recent examples of this is Le Laboratoire in Paris, which runs a year-long program to support collaboration between an artist who has never worked with a scientist and a scientist who has not worked before with artists. The aim is to develop a poetic and conceptually interesting project through a dialogue that can in some way be commercialized. Rather than let markets, technology, or known desires and needs lead the development of a product, cultural ideas drive it; then, at the right moment, it receives investment for realization as a product. The commercial angle particularly suits more conceptual designers because it allows designs intended to explore ideas that would usually remain as exhibition pieces to cross over into everyday life via the marketplace, free from the usual marketing constraints and narrow view of needs and wants that often prevents this from happening. One of the first products of this process was *Andrea* (2009) by Mathieu Lehanneur and David Edwards, an air purifier that uses a living plant to filter dirty air sucked into the device.

Mathieu Lehanneur and David Edwards, *Andrea*, 2009.

Of course this model does not always lead to harmonious outcomes or partnerships. Sometimes an artist may perceive negative implications for the research, but if scientists, or especially a company, opens their laboratory up to an artist or designer and share their research, research that may have taken years to develop, it feels wrong, almost treacherous, to pick up on negative possibilities. This can make it very difficult to deal with possible negative implications for the research. For this reason, other artists such as Eduardo Kac and Natalie Jeremijenko work independently with scientists as advisors rather than creative partners. Here, the artist is free to set his or her own agenda and take on a more critical role.

Eduardo Kac, *Natural History of the Enigma*, transgenic work, 2003-2008. Edunia, a plantimal with the artist's DNA expressed only in the red veins of the flower. Photograph by Rik Sferra.

Eduardo Kac is known for working with living materials, or *transgenic art*, as he terms it. He aims to transfer biotechnology techniques from practical applications to more poetic and philosophical possibilities. For the series *Natural History of the Enigma* Kac created what he calls a *plantimal* named Eudinia (2003-2008)—a genetically engineered hybrid of a Petunia flower and himself, essentially a transgenic flower. The artist's DNA is expressed in the veins of the petals. The artist's gene was isolated and sequenced from his blood, then a new gene was made combining Kac's DNA with a promoter that ensured the red was expressed only in the plant's veins. Although there are all sorts of nuanced meanings and associations in his work, it is the drama of the object itself that gives the work impact, particularly through popular media and press.

Probably one of the most extreme forms of art and science interaction is when the artist becomes a scientist or at least does science but in a nonscientific way. Oron Catts and Ionat Zurr have set up a research laboratory in a biological science department at the University of Western Australia to enable researchers to engage in wet biology practices. Their specialization is tissue culture engineering and they both worked as research fellows at the Harvard Medical School to learn their craft. For them, the doing is as important as the subject and product, and they have complete creative and intellectual independence. Consequently, their work is extremely powerful because they have artistic control over every aspect and stage of creating and presenting their work. For the *Design and the Elastic Mind* exhibition at MoMA (2008) they presented *Victimless Leather: A Prototype of a Stitch-less Jacket Grown in a Technoscientific "Body"* (the first version was developed in 2004) they grew in a local lab. The exhibit had to be kept alive throughout the exhibition and at one point began to grow out of control. After much discussion with Paola Antonelli the curator, it was decided to euthanize the artwork. The press had a field day announcing that a MoMA curator decided to kill an artwork. But the debate it sparked is highly pertinent—how should we manage works of art and products when they are made from living tissue?

The Tissue Culture and Art Project (Oron Catts and Ionat Zurr), *Victimless Leather: A Prototype of Stitch-less Jacket Grown in a Technoscientific "Body"*, 2004. Biodegradable polymer connective and bone cells. Photograph courtesy of The Artists. Hosted at SymbioticA, The University of Western Australia.

BCL (Shiho Fukuhara and Georg Tremmel), two more artists trained as designers usually work with genetically engineered flowers. They situate their work firmly in the messy context of intellectual property, regulations, monopolies, commercial rights, markets, and consumerism. In *Common Flowers/Blue Rose* (2009) they took the first commercially available genetically modified flower, an unnatural blue carnation manufactured by Suntory flowers called Moondust, reverse engineered it, cloned it, and released it into the wild with instructions so others could do the same. The project aims to question ownership of nature and what happens if nature itself is used as the mechanism for reproducing patented natural material. Unlike the more poetic and philosophical work of Kac, BCL's work is subversive and fully engaged with the mechanisms through which research flows from laboratory to marketplace. It can exist in galleries but is about the world beyond its walls.

Shiho Fukuhara and Georg Tremmel, *Common Flowers/Blue Rose*, 2009.

In an earlier project, *Biopresence* (2003), BCL proposed a service in which after death, a person's DNA is inserted into an apple tree as a memorial using a genetic coding technique invented by Joe Davis to store human DNA within a tree or a plant without affecting the genes of the resulting organism. The trees can be thought of as "living memorials" or "transgenic tombstones." From a scientific point of view the project is not as interesting because DNA is just information. But from a layperson's perspective this is a highly symbolic and provocative idea, especially in the case of fruit trees— would you eat an apple from your grandmother's tree?

Their search over several years for funding to be able to offer individually engineered trees highlighted all sorts of issues around the regulation of biotechnological products. In particular the project served as a very powerful vehicle for exploring ethical issues surrounding cross-species gene splicing in a commercial context.

Although impressive that they attempted to realize the project, even though they were unable to implement it, the project demonstrates that it is not always necessary to be "real" to be valuable. A speculative design proposal can also serve as a "probe" for highlighting legal and ethical limits to existing systems. This form of speculative project usually falls outside the context of SciArt. With its emphasis on modeling ideas and projecting into the future, it is probably a more comfortable space for designers than artists and, indeed, most work in this area is by designers.

FUNCTIONAL FICTIONS

For us, this is one of the strengths of design over art in relation to technology: it can pull new technological developments into imaginary but believable everyday situations so that we can explore possible consequences before they happen. And, it can do this with intelligence, wit, and insight. The following examples grew out of a design approach to biotechnology we have been developing with MA students at the Royal College of Art since 2002. The brief does not start with a problem or need but instead asks students to identify a specific area of science research, then to imagine issues that might arise once the research moves from lab to everyday life, and finally to embody these issues in a design proposal aimed at sparking debate or discussion. The project is about using design to ask questions rather than providing answers or solving problems.

In 2006, inspired by Oron Catts and Ionat Zurr's *Tissue Engineered Steak No.1* (2000), we asked our students to explore the implications of this technology if it were to be mass produced. One of the most successful proposals was also one of the most straightforward: James King's *Dressing the Meat of Tomorrow* (2006). His project examined how we might choose to give shape, texture, and flavor to this new sort of food to remind us where it came from in a world in which traditional livestock farming has disappeared. He suggested using a mobile animal magnetic resonance imaging unit to scan the most perfect examples of cows, chickens, and pigs from head to toe creating accurate cross-sectional images of their inner organs. The most interesting and aesthetically pleasing examples of anatomy would be used as templates to create molds for the lab-grown meat. Although still not delicious looking, it moves beyond the "yuck" factor associated with the original prototype and allows for discussion about the pros and cons of the technology.

The Tissue Culture and Art Project (Oron Catts and Ionat Zurr), a study for *Disembodied Cuisine*. Pre-natal sheep, skeletal muscle, and degradable PGA polymer scaffold. Photograph courtesy of The Tissue Culture and Art Project (Oron Catts and Ionat Zurr). Hosted at SymbioticA, The Centre of Excellence in Biological Arts, School of Anatomy, Physiology and Human Biology, The University of Western Australia.

James King, *Dressing the Meat of Tomorrow*, 2006

Would vegetarians eat it because animals would no longer need to be slaughtered or to suffer? Could we eat lab-grown human meat, from a famous pop star perhaps, and would it be for love or malice?

Over the last few years this topic has been revisited many times but recently the focus has shifted onto the bigger picture. In *Biophilia: Organ Crafting* (2011), Veronica Ranner explores where lab-grown meat should be grown and if laboratories are really the most desirable option. She offers an alternative vision based on an artisanal process that combines laboratory and studio into a studiolab. The objects she produced were not product proposals but evocations of what a craft approach to organ building might be like. The purpose was to move the discussion away from brave new world factory visions on the one hand and gothic, Frankenstein scenarios on the other to the possibility of handcrafted artisanal production processes in which biotechnologists become sculptors of organs.

Veronica Ranner, *Organ Crafting*, 2011, from the series *Biophilia*.

Emily Hayes, *Manufacturing Monroe: Quality Control*, 2011.

This is quite a utopian vision reflecting the good intentions of scientists and designers. The trouble starts when science moves out of the laboratory into the marketplace, when consumer desire enters the equation and things become more irrational and profit driven. This is the starting point for *Manufacturing Monroe* (2011) by Emily Hayes. It is a far darker future than Ranner's. It uses the same technology but now it has been reduced to producing souvenirs. The outcome is a highly stylized video that shows glimpses of a tissue engineering factory of the future for manufacturing bits of celebrities—sheets of John F. Kennedy's foreskin, miniature Marilyn Monroe breasts, and sausages of Michael Jackson's brain. Fans can literally own a bit of their idol. Although Hayes's project is lighthearted, this is a serious issue. How do we ensure that the translation of science from lab to everyday life avoids the worst aspects of commercialization once it moves beyond medical applications?

Hayes and Ranner both explore different aesthetic possibilities for the representation of biotechnology. All too often bioart and tissue culture engineering projects end up looking slightly gothic—all test tubes, fluids, and bits of flesh, frequently leaning toward horror. Speculative design projects can provide new forms of visual representation for biotechnology that open up other possibilities for debate, linking the discussion to mass consumerism for instance.

Many of the goals driving tissue engineering are concerned with replacing existing organs or body parts—flesh, hearts, breasts, kidneys, corneas, and so on. What other ways could this technology be used to enhance life rather than simply fix what is damaged or replace what is missing? In *Biophilia: Survival Tissue* (2011), Veronica Ranner looked at growing skin as a surface for a product. She was interested in how this technology could lead to new ways of thinking about medical technologies. As a vehicle for this investigation, she chose an incubator for keeping premature babies alive. This is not a concrete design proposal but a hope for tissue engineering expressed through an imaginary product, in this case an incubator that uses human skin. Its purpose is to ask, Will new biotechnologies enable us to move beyond the current highly technical language of medical technology to a more humane one? Another issue the project touches on is once you start to use semi-living materials such as skin, what happens with built-in obsolescence? Like Oron Catts and Ionat Zurr's *Victimless Leather Jacket*, would we just kill products once they have served their purpose?

Veronica Ranner, *Survival Tissue*, 2011, from the series *Biophilia*.

Along similar lines but less optimistic are Kevin Grennan's proposals for future robots—*The Smell of Control: Trust, Focus, Fear* (2011). He is very critical of anthropomorphism applied to technology because he believes it pushes our Darwinian buttons and creates false emotional ties with machines. Fine when robots are harmless but quite scary once they become more advanced. In this project he wanted to ask how far we are prepared to go in engineering a better fit between humans and robots. He produced three visualizations of robots that use tissue-engineered glands for secreting hormones that affect human behavior in different ways. They are intentionally repulsive.

In the first, about trust, a surgical robot sprays the patient with a hormone before an operation. The second, a factory robot, uses a chemical in male sweat known to calm women and help them focus to improve their productivity. The third, a bomb-disposal robot, produces the smell of fear, known to improve concentration. The project is presented as a series of drawings that immediately communicate its fictional status. There is no attempt here to make us believe they are real but simply to invite us to make-believe.

We already use fresh bread smells in supermarkets to encourage us to buy; how far are we prepared to go in our efforts to close the gap between people and technology, to create seamless interactions and symbiotic relationships with our machines? Is this a future we would like? And, if not, how can we prevent it?

Kevin Grennan, *The Smell of Control: Trust*, 2011.

Revital Cohen, *Respiratory Dog*, 2008, from the series *Life Support*.

Will the ability to design with semi-living tissue change the way we think about other living creatures and animals? In *Life Support* (2008), Revital Cohen proposes using animals bred commercially for consumption or entertainment as companions and providers of external organ replacement. The use of transgenic farm animals or retired working dogs as life support "devices" for renal and respiratory patients offers an alternative to inhumane medical technologies. With this project she asks, Could a transgenic animal function as a whole mechanism and not simply supply the parts? Assistance animals, from guide dogs to psychiatric service cats, unlike computerized machines, can establish a natural symbiosis with the patients who rely on them. Could a transgenic sheep matched to a patient's blood be used as a living kidney dialysis machine? During the night the patient's blood would flow through the sheep, cleansed by its kidneys, and impurities would be urinated out of the system by the sheep in the morning. The project could be described as a form of "speculative ethics"—a tool for exploring notions of future good and future bad.

Ai Hasegawa, *I Wanna Deliver a Shark*, 2012. Photograph by Theo Cook.

But why stop with animals? Ai Hasegawa's *I Wanna Deliver a Shark* (2012) started from the viewpoint of a woman in her thirties troubled by her impulse to give birth, yet for various reasons, not wanting to bring a child into the world or to become a mother. In Hasegawa's scenario the woman decides to use her reproductive capability to help endangered species prolong their existence. After much research and consultation, Hasegawa discovered that although it is not possible to host a dolphin or tuna, her preferred species, it would be technically possible for a woman to host one of the smaller sharks and give birth to it. Although on the surface this project may seem absurd, it raises interesting questions about the reproductive power of a woman's body and, aided by developments in biomedicine, the possibility of using this power for other purposes than simply reproducing our own, rapidly increasing species.

Probably the most philosophical of all these projects is Koby Barhad's *All That I Am: From a Speck of Hair to Elvis Presley's Mouse Model* (2012). Barhad was interested in where exactly the sense of "self" lies, the "me" bit, when it comes to the design of living things. The project set out to design an Elvis Presley mouse. Although technically possible, the project had to remain speculative for ethical reasons. The first step was to acquire some genetic material containing Elvis's DNA, achieved when Barhad managed to purchase one of Elvis's hairs on eBay.[7] The next step would be to have the DNA sequenced to identify behavioral traits such as sociability, athletic performance, and susceptibility to addiction and obesity. Barhad then identified a company that creates mouse models for scientific experiments and would in theory be able to produce a transgenic Elvis mouse using the genetic material he provided. Next, Barhad built a tower of custom designed environments based on ones used in laboratories to test traits in genetically modified mice. Each compartment simulated key biographical moments in Elvis's life.

By going through the process of designing an Elvis mouse based on current technologies, Barhad highlighted the absurdity of thinking of clones as anything more than a material reproduction of another living thing. The final object, the tower, is not only beautiful but it also satirizes the notion of isolating and translating behavioral traits into model environments.

There are no solutions in these projects or even answers, just questions, thoughts, ideas, and possibilities, all expressed through the language of design. They probe our beliefs and values, challenge our assumptions and encourage us to imagine how what we call *nature* could be different. They help us see that the way things are now is just one possibility and not necessarily the best one. Each of these speculative projects occupies a space between reality and the impossible, a space of dreams, hopes, and fears. It is an important space, a place where the future can be debated and discussed before it happens so that, at least in theory, the most desirable futures can be aimed for and the least desirable avoided. Although it is not possible for designers to build actual products using biotechnology yet, we should not let that stop us from getting involved; we can still create functional fictions that help us explore the kind of biotechnological world we wish to live in.

Koby Barhad, *All That I Am: From a Speck of Hair to Elvis Presley's Mouse Model*, 2012. © Koby Barhad.

5.
A METHODOLOGICAL PLAYGROUND: FICTIONAL WORLDS AND THOUGHT EXPERIMENTS

The universe of possible worlds is constantly expanding and diversifying thanks to the incessant world-constructing activity of human minds and hands. Literary fiction is probably the most active experimental laboratory of the world-constructing enterprise.[1]

Although design usually references sculpture and painting for material, formal and graphic inspiration, and more recently the social sciences for protocols on working with and studying people—if we are interested in shifting design's focus from designing for how the world is now to designing for how things could be—we will need to turn to speculative culture and what Lubomír Doležel has called an "experimental laboratory of the world-constructing enterprise."

Speculating is based on imagination, the ability to literally imagine other worlds and alternatives. In *Such Stuff as Dreams* Keith Oatley writes that "[i]magination gives us entry to abstraction, including mathematics. We gain the ability to conceive alternatives and hence to evaluate. We gain the ability to think of futures and outcomes, skills of planning. The ability to think ethically also becomes a possibility."[2]

There are many kinds of imagination, dark imaginations, original imaginations, social, creative, mathematical. There are also professional imaginations—the scientific imagination, the technological imagination, the artistic imagination, the sociological imagination, and of course the one we are most interested in, the design imagination.

FICTIONAL WORLDS

As Lubomír Doležel writes in *Heterocosmica: Fiction and Possible Worlds*, "Our actual world is surrounded by an infinity of other possible worlds."[3] Once we move away from the present, from how things are now, we enter this realm of possible worlds. We find the idea of creating fictional worlds and putting them to work fascinating. The ones we are most interested in are not just for entertainment but for reflection, critique, provocation, and inspiration. Rather than thinking about architecture, products, and the environment, we start with laws, ethics, political systems, social beliefs, values, fears, and hopes, and how these can be translated into material expressions, embodied in material culture, becoming little bits of another world that function as synecdoches.

Although rarely discussed in design beyond the construction of brand worlds and corporate future technology videos, there is a rich body of theoretical work in other fields dealing with the idea of fictional worlds. Probably the most abstract discussion is in philosophy where differences between the many shades of real, fictional, possible, actual, unreal, and imaginary are teased out. In social and political science the focus is on modeling reality; in literary theory it is on the semantics of the real and nonreal; in fine art, make-believe theory and fiction; in game design, literal world creation; and even in science there are many rich strands of discourse around fictionalism, useful fictions, model organisms, and multiverses.[4] For us, the key distinction is between actual and fictional. Actual is part of the world we occupy whereas fictional is not.[5]

Of all these areas of research, it is literature and fine art that offer the most promising sources of inspiration. They can push the notion of fiction to the extreme, going well beyond logical worlds and more pragmatic world building. Although technically a fictional world can be impossible and incomplete, whereas a possible world needs to be plausible, the limit for us is scientific possibility (physics, biology, etc.) everything else—ethics, psychology, behavior, economics, and so on—can be stretched to the breaking point. Fictional worlds are not just figments of a person's imagination; they circulate and exist independently of us and can be called up, accessed, and explored when needed.

The artist Matthew Barney has created extraordinarily complex fictional worlds. His *Cremaster Cycle* (1994-2002) consists of five feature-length films and hundreds if not thousands of individual artifacts, costumes, and props. But although beautiful and exquisitely detailed they are also idiosyncratic to the extreme, an externalization of his own inner world that can only be aesthetically appreciated by others.[6] It is art at its purest—noninstrumental, personal, subjective, and profoundly beautiful. Designers, too, have experimented with fictional worlds. Jaime Hayón's *The Fantasy Collection* (2008) for Lladró, for instance, consists of porcelain souvenirs from a parallel world. In fashion, too, it is common to use advertising to suggest the imaginary world behind the brand, especially for perfumes, which often drift toward a form of contemporary fairy tale. But game design has to be the area where fictional world building is most developed. Whole worlds are designed, visualized, and linked. Some readers probably remember the first time they experienced an open world video game such as *Grand Theft Auto* (1997) and how enjoyable it was to drive around and explore the world created by its designers rather than playing the game. Although extraordinarily detailed, game worlds tend to focus on the setting, geography, and environment more than ideology, and their purpose is primarily escape and entertainment. There is, however, a growing number of artist- and activist-designed games that aim to challenge assumptions about game design, their social and cultural uses, and encourage social change.[7] How this relates to design is something we will return to later in this chapter.

Matthew Barney, *Cremaster 3*, 2002, production still. Photograph by Chris Winget. Photograph courtesy of Gladstone Gallery, New York and Brussels. © 2002 Matthew Barney.

UTOPIAS/DYSTOPIAS

Probably the purest form of fictional world is the utopia (and its opposite, the dystopia). The term was first used by Thomas More in 1516 as the title of his book *Utopia*. Lyman Tower Sargent suggests utopia has three faces: the literary utopia, utopian practice (such as intentional communities), and utopian social theory;[8] for us, the best are a combination of all three and blur boundaries among art, practice, and social theory. In *Envisioning Real Utopias* Erik Olin Wright defines utopias as "fantasies, morally inspired designs for a humane world of peace and harmony unconstrained by realistic considerations of human psychology and social feasibility."[9] There is a view that utopia is a dangerous concept that we should not even entertain because Nazism, Fascism, and Stalinism are the fruits of utopian thinking. But these are examples of trying to make utopias real, trying to realize them, top down. The idea of utopia is far more interesting when used as a stimulus to keep idealism alive, not as something to try to make real but as a reminder of the possibility of alternatives, as somewhere to aim for rather than build. For us, Zygmunt Bauman captures the value of utopian thinking perfectly: "To measure the life "as it is" by a life as it should be (that is, a life imagined to be different from the life known, and particularly a life that is better and would be preferable to the life known) is a defining, constitutive feature of humanity."[10]

And then there are dystopias, cautionary tales warning us of what might lay ahead if we are not careful. Aldous Huxley's *Brave New World* (1932) and George Orwell's *1984* (1949) are two of the twentieth century's most powerful examples. Much has been written about utopias and dystopias in science fiction but there is a particularly interesting strand of sci-fi critique termed *critical science fiction* in which dystopias are understood in relation to critical theory and the philosophy of science.[11] In this reading of science fiction, political and social possibilities are emphasized above all else, a role explored in depth by sci-fi theorist Darko Suvin who uses the term *cognitive estrangement*, a development of Bertolt Brecht's A-effect, to describe how alternate realities can aid critique of our own world through contrast.

EXTRAPOLATION: NEOLIBERAL SPECULATIVE FICTION

Many utopian and dystopian books borrow political systems such as feudalism, aristocracy, totalitarianism, or collectivism from history, but we find the most thought-provoking and entertaining stories extrapolate today's free market capitalist system to an extreme, weaving the narrative around hypercommodified human relations, interactions, dreams, and aspirations.

Many of these stories originate in the 1950s. It's as though, already in the postwar years, writers were reflecting on where the promises of consumerism and capitalism were taking us; yes, they would create more wealth and a higher standard of living for a larger number of people than ever before but what will the impact be on our social relations, morality, and ethics?

Philip K. Dick is the master of this. In his novels everything is marketized and monetized. They are set in twisted utopias where all are free to live as they please but they are trapped within the options available through the market. Or *The Space Merchants* (1952) by Frederik Pohl and Cyril M. Kornbluth, which is set in a society where the highest form of existence is to be an advertising man and crimes against consumption are possible. This view of capitalism is not limited to 1950s and 1960s sci-fi, though, and can be found in contemporary writing. George Saunders's *Pastoralia* (2000) is set in a fictional prehistoric theme park where workers are obliged to act like cave people during working hours and try to negotiate a friendship around the rules, contractual obligations, and expectations of visitors. It is sad and funny but recognizable. Other writers who embrace this exaggerated version of capitalism include Brett Easton Ellis (*American Psycho*, 1991), most of Douglas Coupland's writings, Gary Shteyngart (*Super Sad True Love Story*, 2010), Julian Barnes (*England England*, 1998), and Will Ferguson (*Happiness*, 2003). They expose at a human scale the limitations and failures of a free-market capitalist utopia, how, even if we achieve it, it is humanely reduced. Although not a strong novel by any means, Ben Elton's *Blind Faith* (2007) picks up current trends for dumbing culture down, extrapolating into a near future when inclusiveness, political correctness, public shaming, vulgarity, and conformism are the norm, a world where tabloid values and commercial TV formats shape everyday behavior and interactions.

It can be found in film, too: *Idiocracy* (2006) and *WALL-E* (2008) are both set in worlds suffering from social decay and cultural dumbing down. The most recent example is *Black Mirror* (2012), a satirical miniseries for Chanel Four television in the United Kingdom. It fast-forwards technologies being developed today by technology companies to the point at which the dreams behind each technology turn into nightmares with extremely unpleasant human consequences.

Charlie Brooker, *Black Mirror*, 2012, production still. Photograph by Giles Keyte.

But what does this mean for design? On a visual level, in cinema, a style has developed that is riddled with visual clichés—ubiquitous adverts, corporate logos on every surface, floating interfaces, dense information displays, brands, microfinancial transactions, and so on. Corporate parody and pastiche have become the norm, and although *Black Mirror* has moved well beyond this, it is the exception. Maybe this is one of the limitations of cinema; it can deliver a very powerful story and immersive experience but requires a degree of passivity in the viewer reinforced by easily recognized and understood visual cues, something we will return to in chapter 6. Literature makes us work so much harder because readers need to construct everything about the fictional world in their imagination. As designers, maybe we are somewhere in between; we provide some visual clues but the viewer still has to imagine the world the designs belong to and its politics, social relations, and ideology.

IDEAS AS STORIES

In these examples, it is the backdrop that interests us, not the narrative; the values of the society the story takes place in rather than the plot and characters. For us, ideas are everything but can ideas ever be the story?

In the introduction to *Red Plenty* (2010) Francis Spufford writes, "This is not a novel. It has too much to explain, to be one of those. But it is not a history either, for it does its explaining in the form of a story; only the story is the story of an idea, first of all, and only afterwards, glimpsed through the chinks of the idea's fate, the story of the people involved. The idea is the hero. It is the idea that sets forth, into a world of hazards and illusions, monsters and transformations, helped by some of those it meets along the way and hindered by others."[12] *Red Plenty* explores what would have happened if Soviet communism had succeeded and how a planned economy might have worked. It is a piece of speculative economics exploring an alternative economic model to our own, a planned economy where everything is centrally controlled, and it unapologetically focuses on ideas. This approach is similar to design writing experiments such as *The World, Who Wants it?* by architect Ben Nicholson and *The Post-spectacular Economy* by design critic Justin McGuirk.[13] Both are stories of ideas exploring the consequences for design of major global, political, and economic changes—Nicholson's in a dramatic and satirical way and McGuirk through a more measured approach beginning with real events that morph before our eyes into a not so far-fetched near future. But these are still literary and although both contain many imaginative proposals on a systemic level, they do not explore how these shifts would manifest themselves in the detail of everyday life. We are interested in working the other way around—starting with designs that the viewer can use to imagine the kind of society that would have produced them, its values, beliefs, and ideologies.

In *After Man—A Zoology of the Future* (1981) Dougal Dixon explores a world without people focusing exclusively on biology, meteorology, and environmental sciences. It is an excellent if slightly didactic example of a speculative world based on fact and well-understood evolutionary mechanisms and processes expressed through concrete designs, in this case, animals.

Fifty-million years into the future, the world is divided into six regions: tundra and the polar, coniferous forests, temperate woodlands and grasslands, tropical forests, tropical grasslands, and deserts. Dixon goes into impressive detail about the climate, distribution, and extent of different vegetation and fauna as he sketches out a posthuman landscape on which new kinds of speculative life forms evolve. Each aspect of the new animal kingdom is traced back to specific characteristics that encourage and support the development of new animal types in a human-free world. Each animal relates to ones we are familiar with, but because of an absence of humans, evolve in slightly different ways. A flightless bat whose wings have

Dougal Dixon, "Flooer" and "Night Stalker," from *After Man:*
A Zoology of the Future (London: Eddison Sadd Editions, 1998).
Image courtesy of Eddison Sadd Editions. © 1991 and 1998 Eddison
Sadd Editions.

evolved into legs still uses echolocation to find its prey but now, because an
increase in size and power, it stuns its victims. The book is a wonderful
example of imaginative speculation grounded in systemic thinking using little
more than pen-and-ink illustrations. It could so easily have been a facile
fantasy thrilling us with the weirdness of each individual creature, but by
tempering his speculations, Dixon guides us toward the system itself and the
interconnectedness of climate, plant, and animal.

As well as highly regarded works of literature, Margaret Atwood's novels are stories of ideas. *Oryx and Crake* sets out a postapocalyptic world populated by transgenic animals and beings developed by and for a society comfortable with the commercial exploitation of life: pigoons bred to grow spare human organs, for instance. *Oryx and Crake* is very close to how a speculative design project might be constructed. All her inventions are based on actual research that she then extrapolates into imaginary but not too far-fetched commercial products. The world she creates serves as a cautionary tale based on the fusion of biotechnology and a free-market system driven by human desire and novelty, where only human needs count. Unlike many sci-fi writers, Atwood is far more interested in the social, cultural, and ethical implications of science and technology than the technology itself. She resists the label of sci-fi preferring to describe her work as speculative literature. For us, she is the gold standard for speculative work—based on real science; focused on social, cultural, ethical, and political implications; interested in using stories to aid reflection; yet without sacrificing the quality of storytelling or literary aspects of her work. Similar to Dixon's *After Man* the book is full of imaginative and strange designs but based on biotechnology. Each design highlights issues as well as entertaining and moving the story along.

Whereas *Oryx and Crake* creates plausibility through an extrapolation of current scientific research, one of our favorite books, Will Self's *The Book of Dave* uses a far more idiosyncratic mechanism for establishing a link with today's world. It is the story of a future society built around a book written hundreds of years earlier by an alcoholic, bigoted, and crazed London taxi driver going through a messy divorce. Buried in his ex-wife's back garden in Hampstead, he hopes his estranged son will discover the book one day. He doesn't, and it is dug up hundreds of years later after a great flood has wiped out civilization as we know it. Basing the logic underlying a future community's social relations on a dysfunctional taxi driver's prejudices shows how random our customs can be and how brutality and social injustice can be shaped by strange, fictional narratives. That these lead to so much sadness and misery is tragic, and this book captures the ridiculousness of political and religious dogma. Besides the motos, a kind of genetically modified animal that seems to be a cross between a cow and a pig that speaks in a disturbing childlike manner, most of the inventions are customs, protocols, and even language. Children spend part of each week living with each parent on opposite sides of the street, young women are called au pairs, days are divided into tariffs, souls are fares, priests are drivers, and so on. The *Book*

of Dave is a dense, inventive, highly original, complex, and layered portrayal of a fictional world. But is it possible to apply this to design? We think it is. Unlike *Oryx and Crake*, it is not Self's inventions that inspire but his method and how rich and thought-provoking fictional worlds can be developed from idiosyncratic starting points.

China Miéville's *The City and the City* is based on poetic and contemporary ideas about artificial borders. Two cities, Beszel and Ul Qoma coexist in one geographical zone, in one city. A crime is committed that links the two cities so the protagonist, inspector Tyador Borlú, must work across borders to solve it, something that's usually avoided at all costs because citizens of each city no longer see or acknowledge each other even while using the same streets and sometimes the same buildings. To see the other city or one of its inhabitants is a "breach," the most serious of all crimes imaginable. It is a wonderful setting that makes not only for a fascinating detective story but also prompts all sorts of ideas about nationality, statehood, identity, and ideological conditioning to surface in the reader's imagination. As Geoff Manaugh points out in an interview with the author, it is essentially poli-sci fiction.[14] Everything in this book is familiar; it is the reconceptualization of a simple and familiar technical idea, the border, that makes it relevant to design, again, more for its method than its content.

As literary fictional worlds are built from words there are some rather special possibilities that can be explored by pushing language's relationship to logic to the limit, a bit like the literary equivalent of an Escher drawing. A recent example of this is *How to Live Safely in a Science Fictional Universe* (2010) by Charles Yu. Here, fictional worlds provide opportunities to play with the very idea of fiction itself. Yu's world is a fusion of game design, digital media, VFX, and augmented reality. Set in Minor Universe 31, a vast story-space on the outskirts of fiction, the protagonist Yu is a time travel technician living in TM-31, his time machine. His job is to rescue and prevent people from falling victim to various time travel paradoxes. *How to Live Safely in a Science Fictional Universe* feels like conceptual science fiction: the story unfolds through constant interactions, collisions, and fusions among real reality, imagined reality, simulated reality, remembered reality, and fictional reality.

Can design embrace this level of invention or are we limited to more concrete ways of making fictional worlds? One strength for design is that its medium exists in the here and now. The materiality of design proposals, if expressed through physical props, brings the story closer to our own world away from the worlds of fictional characters. *How to Live Safely in a Science*

Fictional Universe makes us wonder about speculative design's complex relationship to reality and the need to celebrate and enjoy its unreality.

THOUGHT EXPERIMENTS

One way this might be possible is to treat design speculations not as narratives or coherent "worlds" but as thought experiments—constructions, crafted from ideas expressed through design—that help us think about difficult issues.

Thought experiments are probably closer to conceptual art than they are to conventional design. But it is too easy to focus only on the experiment part; it is the thought bit that makes them interesting and inspirational for us. They allow us to step outside reality for a moment to try something out. This freedom is very important. Thought experiments are usually done in fields where it is possible to precisely define limits and rules, such as mathematics, science (particularly physics), and philosophy (especially ethics) to test ideas, refute theories, challenge limits, or explore possible implications.[15] They make full use of the imagination and are often beautiful designs in themselves.[16]

Writers often base short stories on thought experiments, fusing narrative and concept to produce functional fictions designed to get people thinking about something specific in an enjoyable way. Edwin Abbott's *Abbott's Flatland: A Romance of Many Dimensions* (1884) is a good example. It explores interactions between worlds with different dimensions, 1D, 2D, 3D. . . . When a sphere passes perpendicularly through 2D land, none of its inhabitants understand how the bit they see, a disc, can expand and contract in the way it does.

REDUCTIO AD ABSURDUM

One of our favorite forms of thought experiment uses reductio ad absurdum, a type of logical argument in which one assumes a claim for the sake of argument and derives an absurd or ridiculous outcome by taking it to its extreme, concluding that the original claim must have been wrong because it led to such an absurd result. It lends itself well to humor, too. Thomas Thwaites's *The Toaster Project* (2009) is a good example.

Thwaites set out to build a toaster from scratch. On taking apart one of the cheapest ones he could find he was surprised to discover that it was made up of 404 different parts, so he decided to focus on five materials: copper, iron, nickel, mica, and plastic. Over the next nine months he visited mines, extracted iron from ore, tracked down mica in Scotland, and eventually made

Thomas Thwaites, *The Toaster Project*, 2009. Photograph by Daniel Alexander.

Thomas Thwaites, *The Toaster Project*, (cover removed) 2009. Photograph by Daniel Alexander.

an almost working toaster. Thwaites knew from the start it was an impossible task but used the quest, which was recorded on video and later published as a book, to highlight how dependent we have become on technology and how far removed we are from the processes and systems behind most of the technologies and devices our everyday lives depend on. The project also highlighted what goes into making even a simple product like a toaster, or maybe, the absurdity of what has to be done to lightly burn a piece of bread each morning. At one point he researches what he would need to smelt iron ore and discovered the last point in history when it was possible for one person to do so was in the fifteenth century. After several failed attempts at replicating the set-up using modern devices such as hairdryers and leaf blowers instead of bellows, Thwaites discovered a patent that used microwaves to smelt iron ore and, using his mother's microwave and some modifications, he managed to extract a small amount of iron. Sometimes people are disappointed to learn he used modern technologies but the project was never about going back to basics; it was always about highlighting just how complex and difficult the processes behind even the most simple of everyday conveniences, like toasting a piece of bread, have become.

COUNTERFACTUALS

Another well-established form of thought experiment is the counterfactual. A historical fact is changed to see what might have happened, if. . . . It is sometimes used in history to understand the importance of key events and their influence on how the world turned out. A famous example is how the world might have been if Hitler had won World War II, a theme explored in many works of fiction. For writers, it is an interesting way of creating an alternative present because the reader can understand how that alternate world might have come about. For design it can provide a fresh alternative to future-based thinking by presenting parallel worlds as thought experiments rather than predictions. But it can be slightly cumbersome because of the need to set up the story before people can engage with the project. James Chambers's *Attenborough Design Group* (2010) is a simple example of how this approach might translate into a design project.

Chambers asks, What if David Attenborough had become an industrial designer rather than a wildlife filmmaker, who, still fond of nature, established the Attenborough Design Group to explore how animal behavior could be used to equip technology products with survival instincts: a Gesundheit radio, which sneezes periodically to expel potentially damaging dust, and *Floppy Legs*, a portable floppy disc drive that stands up if it

James Chambers,
*Attenborough Design
Group: Radio
Sneezing*, 2010.
Photograph by Theo
Cook.

James Chambers,
*Attenborough Design
Group: Hard Drive
Standing*, 2010.
Photograph by J.
Paul Neeley.

detects liquid nearby? The project opens new perspectives on sustainability by suggesting that if products were equipped with sensors they could dodge danger and survive longer before ending up in a landfill. They would also have the added benefit of creating strong emotional ties with their owners because of carefully designed animal-like behaviors that encourage people to project emotions onto them. By going back in time, Chambers was able to shift attention from visual aesthetics to designing animal-inspired behaviors for technology products.

A more elaborate example of this approach is Sascha Pohflepp's *The Golden Institute* (2009). Pohflepp revisited a moment in history when a very different America could have developed: "The Golden Institute for Energy in Colorado was the premier research and development facility for energy technologies in an alternate reality where Jimmy Carter had defeated Ronald Reagan in the US election of 1981. Equipped with virtually unlimited funding to make the United States the most energy-rich nation on the planet, its scientific and technical advancements were rapid and often groundbreaking." He then developed a number of large-scale project proposals including turning Nevada into a weather experimentation zone causing a gold rush of lightning energy harvesters and making modifications to freeways so they became energy-generating power plants. The project was presented through a variety of media, including a corporate video presentation explaining The Golden Institute's history, structure and mission, a model of its HQ, and drawings and images of design proposals.

Sascha Pohflepp, *Painting of a Geoengineered Lightning Storm over Golden, Colorado*, 2009, from the series *The Golden Institute*.

Sascha Pohflepp, *Model of a Chevrolet El Camino Lightning Harvester Modification* (side), 2009, from the series *The Golden Institute*.

Sascha Pohflepp, *Model of an Induction Loop-equipped Chuck's Cafe Franchise by Interstate 5, Colorado*, 2009, from the series *The Golden Institute*.

WHAT-IFS

Related to counterfactuals but more forward looking are what-if scenarios. They allow the author to strip narrative and plot right down to basics in order to explore an idea. What-ifs were often used in a very particular form of English science fiction common in 1950s (e.g., John Christopher, Fred Hoyle, and John Wyndham). John Wyndham, for instance, wrote several novels he termed *logical fantasy* around dramatic what-ifs based on invasions by different kinds of aliens, not just the outer space variety (e.g., *The Kraken Wakes*, *The Midwhich Cuckoos*, and *The Day of the Triffids*). One of the qualities we like about his work is that he explores what might happen in a society in extreme circumstances, a sort of literary rehearsal involving individuals, elites, the government, media, and army. They unpick where, why, and how things could break down or go wrong. They are large-scale thought experiments about how British society might react to extreme disasters and in what ways lives may change as a consequence. They tend to focus on one major event, such as the escape from a laboratory of genetically modified killer plants, then follow through on fairly straightforward implications. Their lack of apocalyptic drama and focus on middle-class British characters has led to the genre being termed *cozy catastrophes* by British author Brian Aldiss.

What-ifs work well in cinema, too, as a simple way of excusing oneself from reality in order to entertain an unnatural idea. *Dog Tooth* (2009) by Yorgos Lanthimos sets up an intriguing but simple premise from which all sorts of surprising and disturbing interactions between family members and the outside world take place. Two children are brought up to believe a number of myths created by their parents that shape their understanding of social relations, the outside world, and even language: the word for *sea* is *chair*, planes flying overhead are *toys*, cats are the most ferocious animal in the world, and the way to protect yourself against a cat is to drop to all fours and begin barking, and so on. Inhabiting this alternative linguistic world-model created by their parents, the children's interactions between themselves and with outsiders and the world slowly spiral into chaos.

But we are designers not writers. We want to build things that create similar levels of reflection and pleasure but use the language of design. How can we do this? What happens when speculations move from behind the screen or from the pages of a book to coexist in the same space as the viewer?

SlaveCity—Cradle to Cradle (2005-) by Atelier Van Lieshout (AVL) is a very nice example of what-if thinking applied to design, even though Van Lieshout is an artist. AVL explores what size city could be supported if we

used humans as slaves to produce energy and even as a source of energy themselves or as raw material. The project addresses how such a process would be designed, what equipment would be needed, how much space, the kind of buildings, machinery, and so on. AVL also explores, in detail, how the city would work economically and its optimal scale. The viewer never sees the whole system, just drawings of various scenes, architectural models, and prototype machinery. As outlandish as it is, *SlaveCity* is still based on logic and is closer to the logical fantasy of John Wyndham and other writers than Charles Yu's *How to Live Safely in a Science Fictional Universe.* The challenge for us is how to go beyond this and embrace the full aesthetic potential of working with unreality.

Atelier Van Lieshout, *Welcoming Center*, 2007.

FICTIONEERS IN DENIAL

The problem with speculation, for designers at least, is that it is fictional, which is still seen as a bad thing. The idea that something is not "real," when *real* means it is available in shops, is not good. Yet designers participate in the generation and maintenance of all sorts of fictions, from feature-heavy electronic devices meeting the imaginary needs of imaginary users, to the creation of fantasy brand worlds referenced through products, their content, and their use. Designers today are expert fictioneers in denial. Although there have always been design speculations (e.g., car shows, future visions, haute couture fashions shows), design has become so absorbed in industry, so familiar with the dreams of industry, that it is almost impossible to dream its own dreams, let alone social ones. We are interested in liberating this story making (not storytelling) potential, this dream-materializing ability, from purely commercial applications and redirecting it toward more social ends that address the citizen rather than the consumer or perhaps both at the same time.

For us, the purpose of speculation is to "unsettle the present rather than predict the future."[17] But to fully exploit this potential, design needs to decouple itself from industry, develop its social imagination more fully, embrace speculative culture, and then, maybe, as MoMA curator Paola Antonelli suggests, we might see the beginnings of a theoretical form of design dedicated to thinking, reflecting, inspiring, and providing new perspectives on some of the challenges facing us.[18]

As the author Milan Kundera writes: "A novel examines not reality, but existence. And existence is not what has occurred, existence is the realm of human possibilities, everything that man can become, everything he's capable of. Novelists draw up the map of existence by discovering this or that human possibility."[19]

We think designers should strive for this, too.

6.
PHYSICAL FICTIONS:
INVITATIONS TO MAKE-BELIEVE

As science fiction author Bruce Sterling pointed out in a public conversation with us about design fiction, there are many forms of fictional objects outside art and design, including patents and failed inventions.[1] These are fictional objects but they are accidental fictions. We are more interested in intentional fictional objects, physical fictions that celebrate and enjoy their status with little desire to become "real."

One way of considering the fictional objects of speculative design is as props for nonexistent films. On encountering the object, the viewer imagines his or her own version of the film world the object belongs to. Film prop design, therefore, might seem like good source of inspiration for these

objects but as Piers D. Britton points out in "Design for Screen SF,"[2] film props have to be legible and support plot development; they have to be readable, which undermines their potential to surprise and challenge. They are instrumental in moving the plot along. As director Alfonso Cuarón puts it when talking about his film *Children of Men* (2006), "Also rule number one in the film is recognisability. We don't want to do *Blade Runner*—actually, we talk about being the anti-*Blade Runner* in the sense of how we were approaching reality. And that was kind of difficult for the Art Department, because I would say, 'I don't want inventiveness, I want reference'. [. . .] And, more important, I would like, as much as possible, references of contemporary iconography that is already ingrained in human consciousness."[3]

This is the main difference between film props and the fictional objects of design speculations. The objects used in design speculations can extend beyond a filmic support function and break away from clichéd visual languages that prop designers are often obliged to use. Yes, it makes reading the objects more difficult but this process of mental interaction is important for encouraging the viewer to actively engage with the design rather than passively consuming it. This separates design speculations from design for cinema. The presence of the prop in the same space as the imaginer also makes the experience more vivid, more alive, and more intense. For example Patricia Piccinini's *The Young Family*[4] (2002) consists of a hyper-realistic life-size model of a transgenic creature with vaguely human characteristics suckling her children. The object is shocking and powerful. It is neither an argument for nor against biotechnology but is simply one possible future lying ahead of us and it is up to the viewers to decide for themselves if they agree or not. Although the object is presented in hyper-realistic detail, the world it belongs to will be different for each person who sees it.

PROPS AND MAKE-BELIEVE THEORY

A more useful way of thinking about the fictional objects of speculative design is Kendall L. Walton's theory of make-believe: props are objects that "prescribe imaginings" and "generate fictional truths." Being "caught up in a story" means "to participate psychologically in a game in which the story (or play or painting) is a prop."[5] Props used in design speculations are functional and skillfully designed; they facilitate imagining and help us entertain ideas about everyday life that might not be obvious. They help us think about alternative possibilities—they challenge the ideals, values, and beliefs of our society embodied in material culture.

Patricia Piccinini, *The Young Family*, 2002. Photograph by Graham Baring. Photograph courtesy of the artist and Haunch of Venison.

The speculative prop designer needs to be skilled at triggering an imaginative response in the viewer but the viewer already has to be open to imagining other ways life could be. When we read a book we build the world alluded to in it in our imagination, but the main purpose is to identify with characters and situations beyond our own lives, to put ourselves in the position of others, for entertainment or reflection. It takes imaginative effort but the result is the viewer or reader takes ownership of the idea, and each experience is diffcrent. Films also require us to put ourselves in the place of the protagonist but they require less effort because we are immersed in a high-resolution world designed to push our emotional buttons. The props of speculative design are different. They are triggers that can help us construct in our minds a world shaped by different ideals, values, and beliefs to our own, better or worse, that we can entertain and reflect on.

Whereas a child uses props to imagine a box is a house or a rock is an alien, speculative design props are intended not to mimic reality or allow us to play act but to entertain new ideas, thoughts, and possibilities for an alternative world from the one we and the prop coexist in, what Kendall calls "fictional propositions" in contrast to the "fictional truths" of children's props.[6] The prop belongs to its own fictional world; it expands our imaginative horizons and provides new perspectives. Toys such as dolls and guns stand in for real guns and people and allow the child to participate in a game of make-believe with predefined rules. Heavily branded products work in a similar way to children's toys allowing their owner to act out a role—important executive, wealthy playboy, creative genius. Speculative design props do not stand in for the real thing and do not fit into predefined behavioral schema; they are physical fictions, departure points for sophisticated imaginings never meant to be viewed as "real," or to reflect reality.

For some, the term *prop* means a fake object, something that doesn't work, but in the context of a speculative design, a prop can be a fully working prototype or not. This is not the issue; its purpose is to facilitate imagining. What makes them different from products is that they do not "fit" into today's world, especially the commercial world. This is what makes them "unreal." They are at odds with how things are. It is the emphasis on transporting the imagination that distinguishes them from other object types including products, prototypes, and models.

Speculative design props function as physical synecdoches, parts representing wholes designed to prompt speculation in the viewer about the world these objects belong to. This approach requires viewers to creatively engage with the props and make them their own. There is a skill and craft to positioning a speculative design, "what the reader or viewer does is to project meanings into the work of art, not any meanings but choices from a family of meanings that the work suggests."[7] The Islanders[8] (1998-) by artist Charles Avery does this beautifully. For more than a decade he has worked on one project, an imaginary island, producing work based on the observations a fictitious traveler has brought back. The project consists of drawings, objects, models, found bones, and so on through which the island can be imagined.

Charles Avery, *Duculi*, 2006. Photograph courtesy of the artist.

USER AS IMAGINER

Props require a shift in the role of viewers, too; they must become active "imaginers." This is something people do when they visit museums to view historical artifacts, often carrying out a sort of imaginary archeology on the artifacts on display. Prefigurative futures (or pre-enactments?) also use props to transport viewers' imagination[9] but, whereas in this role they are bringing a specific future to the present so that it can be partially experienced in advance, user-tested, or prepared for, we are more interested in using props to transport viewers' imagination into a thought experiment, or what-if, and allow enough room for them to make their own interpretations.

Viewers need to understand the rules of the game and how a speculative design prop is meant to function in a given situation. This is very difficult because viewers are not used to encountering designed objects with this purpose either in the press or exhibitions. The closest relatives we can think of are historical everyday artifacts in museum collections that prompt us to imagine what life must have been like in those societies. One challenge for design criticism is to clarify and promote new rules and expectations for viewing speculative design objects in noncommercial settings such as museums and galleries as props designed to trigger social imagining and critical reflection on alternative possibilities for our technologically mediated lives.

SUSPENSION OF DISBELIEF

There is a very important difference between inviting viewers to "make-believe" and asking them to "believe." For props to work, viewers have to suspend their disbelief, willingly. They have to agree to believe in it. This creates the most room for aesthetic experimentation because it frees the design from mimicking reality and referencing the already known.

Asking people to believe can very quickly lead to faking, trickery, and hoaxes. We also avoid parody and pastiche that pretend to be real. We prefer to acknowledge that a prop is a fiction by slightly exaggerating its unreality and signaling that it is an invitation to imagine, speculate, and dream. It takes imagination from the viewer and goodwill but the alternative seems unfair and possibly even unethical. For us, fooling the viewer into believing something is real is cheating. We prefer viewers to willingly suspend their disbelief and to enjoy shifting their imagination into a new, unfamiliar, and playful space.

Plant Fiction (2010) by the design collective Troika, does this well. The project consists of five scenarios, each based on a fictitious plant species mixing fact and fiction to address a very specific issue such as pollution, energy, or recycling through its design. Each is accompanied by a short text hinting at its purpose and situating it in a particular location in a near-future London. *Selfeater (Agave autovora),* for example, breaks down its own cellulose to aid ethanol fermentation and is located beneath the elevated motorways near Barrier Point Road. The images are precise, hyper-realistic computer renderings of visually plausible but technically fictional plants on white backgrounds that subtly communicate their status as speculative designs.

Troika, *Plant Fiction: Selfeater (Agave autovora)*, 2010.
Photograph © Troika 2010.

There is another subtle distinction that needs to be managed during the creation of speculative design props: the difference between believable and plausible. It is sometimes said in TV and cinema that "you can ask an audience to believe the impossible, but not the improbable,"[10] or as James Wood writes in *How Fiction Works*, "This is surely why Aristotle writes that a convincing impossibility in mimesis is always preferable to an unconvincing possibility."[11] A speculative design prop does not need to be realistic, just plausible. This is extremely difficult to get right and is at the aesthetic heart of designing props for make-believe. Within a particular context or world, which may be impossible, certain things are still improbable. For example, if we are watching a film in which a group of people are on their way to Mars and are suddenly confronted by an alien in the ship, if their reaction to the alien does

not match what we would expect, then everything falls apart. Yet, the whole premise, including the existence of aliens, is a fiction that we accept. Once viewers understand the rules they are very strict about allowing themselves to break them. Inconsistency is the issue; there has to be internal consistency within the world the prop belongs to.

DESIGN VOICE

Designing for unreality has its own aesthetic rules. Somehow these objects, scenes, characters, interactions, and activities must appear "real" but gently signal that they are not. They must be plausible but not necessarily believable. In everyday life products usually need to be subdued; for props, drama becomes important. In everyday life we design for users and the design language needs to be transparent and natural. In fiction we are designing for a viewer or imaginer and the design language needs to be unnatural and even glitchy.

In *How Fiction Works*, James Wood writes,

> the novelist is always working with at least three languages. There is the author's own language, style, perceptual equipment, and so on; there is the character's presumed language, style perceptual equipment, and so on; and there is what we could call the language of the world—the language which fiction inherits before it gets to turn it into novelistic style, the language of daily speech, of newspapers, of offices, of advertising, of the blogosphere and text messaging. In this sense the novelist is a triple-writer, and the contemporary novelist now feels especially the pressure of this tripleness, thanks to the omnivorous presence of the third horse of this troika, the language of the world, which has invaded our subjectivity, our intimacy, the intimacy that James thought should be the proper quarry of the novel, and which he called (in a troika of his own) "the palpable present-intimate."[12]

We believe this is true for design props as well, that props can have multiple voices or languages, or more accurately, perspectives they can be designed from. The most interesting voice, or perspective to design from, for us, and probably most neglected, is the designer's own language. Usually this is missing in design fictions because designers try to make their design prop as "realistic" as possible by using the prop's presumed language, the language of the world as we understand it, for example, mass manufacture,

corporate, do-it-yourself, and so on, what people expect and understand design to mean and look like in a specific context. In *Toys* (2009) by designer Tommaso Lanza, the fictional products he designed intentionally conform to what we expect technological products bought by a corporate bank to look like (the language of the world). Here the designer imports the design language of a specific world into the fiction. Our own project, *Technological Dreams No.1: Robots* (2007), is expressed through our own design language, the language of the designer and author, which intentionally does not connect with a viewer's expectation of what robots should look like. And in Sputniko's *Menstruation Machine* (2010) the designer embeds herself in the fictional world of the project and uses the presumed language of the main character, the builder of the DIY device. The prop's "voice" is often overlooked but offers interesting possibilities for playing with viewers' expectations to create deeper engagement.

Dunne & Raby, *All the Robots*, 2007, from the project *Technological Dreams No. 1: Robots*, 2007. Photograph by Per Tingleff.

Tommaso Lanza, *Shredders*, 2009, from the series *Playgrounds/Toys*.
© Tommaso Lanza/The Workers Ltd.

Tommaso Lanza, *Shoe*, 2009, from the series *Playgrounds/Toys*.
© Tommaso Lanza/The Workers Ltd.

Sputniko, *Menstruation Machine*, 2010. Photograph by Rai Royal.

DESIGN FICTION

Speculative design overlaps with several other emerging design approaches but design fiction is probably the closest, and the terms are often used interchangeably. It is a vaguely defined space where speculative, fictional, and imaginary design all collide and fuse. Although there are obvious similarities, we think there are some important differences. Bruce Sterling defines design fiction as "the deliberate use of diegetic[13] prototypes to suspend disbelief about change,"[14] which could also describe a precursor of design fiction sometimes referred to as "artifacts from the future." As it is popularly understood, design fiction is a narrower genre. It has grown out of the technology industry, and as the "fiction" part of the label references science fiction rather than general fiction, it places a strong emphasis on technological futures. Because of this, design fiction is increasingly being understood as a genre of future vision video (sometimes photos but rarely stand-alone objects) designed specifically for circulation on the Internet rather than in exhibitions. Another variation is Brian David Johnson's idea of sci-fi prototyping, which is a more applied version that focuses specifically on using fiction to quickly explore implications for technology in workshops.[15] Inevitably, design fiction suffers from some of the issues associated with film props mentioned at the beginning of this chapter, namely, a dependence on referencing the already known. We are more interested in using fictional designs to suggest things can be very different indeed, consequently our fictions are glitchy, strange, disruptive, and hint at other places, times, and values.

We do of course still use film and photography but rather than using them to ground the designs in "reality" or designing specifically for video, we prefer to use them to extend the imaginative possibilities of the physical prop, adding more layers and opening up more possibilities. Video and photography are secondary media. The physical prop is the starting point for a chain reaction developed through other media rather than a reality anchor for the video.

Like Margaret Atwood's preference for the term *speculative literature* over *science fiction*, we prefer the term *speculative design* over *design fiction*. Although, strictly speaking, we produce fictional designs, they have a broader purpose than the design fiction genre allows. Another difference that separates design fictions from the kind of fictional design we are interested in is that they are rarely critical of technological progress and border on celebration rather than questioning.

7.
AESTHETICS OF UNREALITY

Fiction is both real and not-real in the same way. It is about real social worlds, but it's also imagined.[1]

How do you design for unreality, and what should it look like? How should the unreal, parallel, impossible, unknown, and yet-to-exist be represented? And how, in a design, can you simultaneously capture the real and not-real? This is where the aesthetic challenge for speculative design lies, in successfully straddling both. To fall on either side is too easy.

As designers working outside a strictly commercial context and aiming to engage people with complex ideas, one could argue that similar to film, our designs should be about clear communication. But for us, this assumes a simple model of engagement based on transmitting meaning to a passive viewer. We think it is better to engage people through a skillful use of ambiguity, to surprise, and to take a more poetic and subtle approach to interrelationships between the real and the unreal.

This chapter focuses on the poetics of speculation in the classic sense of how speculation works but also in the sense of poetry—compressed, layered meaning. Literature deals with the possibilities of human nature whereas design deals with the possibilities of human nature manifested in machines and systems.[2] At their most abstract, speculative designs are a form of speculative philosophy of technology that question the meaning of technology itself.

BEYOND PARODY, PASTICHE, AND CLICHÉ

A pitfall with many speculative design projects is a clumsy use of parody and pastiche. To maintain links to the world as we know it, designers try too hard to reference what is already known. It is not a case of mimicking other design languages but the language of everyday design, whether it be corporate, high tech, or high style. It comes from an overeagerness to make speculations seem real. In this chapter we explore aesthetic potential beyond realism, embracing and celebrating the unreal status of speculative design props.

AESTHETICS AND SPECULATION

When we think of the aesthetics of speculation, very specific examples of 1970s and 1980s science fiction imagery immediately spring to mind: illustrators such as Syd Mead and Chris Foss, for example. Interestingly, although many early examples look like computer-generated images (CGIs), they are painted, and one can't help but wonder if they actually influenced the look and feel of today's computer graphics technology. Over the years the use of CGI has evolved enormously in terms of technology but not so much aesthetically. The tools dominate the look and feel of the imagery they are used to create and it is very difficult for an artist, designer, or architect to transcend the dominant style. In a way, the software is the voice behind the imagery. It is not much different in design; although the hyperrealistic computer graphic *Nonobjects* (2010) of Branko Lukić are seductive, their CGI look firmly locates them in a recent tradition of speculative design exercises.[3] The most exciting nonobject for us is *nUCLEUS*, Lukić's design for a motorbike, because of its highly abstracted nonmotorbike form and its

Chris Foss, *The Grain Kings*, 1976. © chrisfossart.com.

Nonobject (Branko Lukić), *nUCLEUS Motorcycle*, 2004.

seductively ambiguous plausibility. One way of breaking this stalemate is to experiment with using CGI to present mixed realities, something the design studio Superflux does beautifully in its *Song of the Machine* (2011) project. The video shows the world seen through a prosthetic device for people with reduced vision. Rather than simply replacing what has been lost, the proposal suggests technology could be used to enhance our vision, letting the wearer see parts of the light spectrum beyond human capability, infrared and ultra violet, for example. It is also possible to see augmented reality superimposed directly onto reality rather than in a hand-held device.

Superflux (Anab Jain and Jon Arden), *Song of the Machine, The Film*, 2011.

After film, advertising is possibly the area in which CGI techniques are most used but usually to create obviously impossible situations that are uninteresting or escapist fantasies. But two recent examples caught our attention. One is the Roy Castle Lung Cancer Foundation's *Molly, Sam, Charlotte* (2008) secondhand smoke awareness campaign consisting of photographs of children with adult arms holding smoking cigarettes, the adult arm being their parent's. Rather than trying to make something fantastical, it uses CGI to make a very disturbing but simple image. The second is the *Anything Can Fly* (2011) promotion advert for Avios's rebranded air miles. When we first saw it we assumed it used CGI and were delighted to discover it

used real objects modified to fly like helicopters. The video shows everyday household products such as coffee makers, barbecues, and washing machines gently and happily floating through the air to a dreamy sound track. The idea is to suggest that buying household products can translate into air miles but the advertisement is so much more evocative than that.

Chi and Partners for The Roy Castle Lung Cancer Foundation, *Molly, Sam, Charlotte*, 2008. Photograph by Kelvin Murray. Creative Team: Nick Pringle and Clark Edwards.

John Hejduk, page from *Vladivostok* sketchbook,
1989. Photograph courtesy of Collection Centre Canadien
d'Architecture / Canadien Centre for Architecture, Montréal.

 Too many visionary schemes suffer from an excess of realism that invites pragmatic critique undermining their inherent poetry and power to inspire. Illustration is an area in which the aesthetics of unreality in varying degrees of abstraction can be enjoyed. The architect John Hejduk has produced a body of highly speculative projects expressed through books of hand-drawn sketches such as *Mask of Medusa* (1985) and *Vladivostok: A Trilogy* (1989).

Ettore Sottsass, *The Planet as Festival: Gigantic Work, Panoramic Road with View on the Irrawaddy River and the Jungle, project. Aerial perspective*, 1973. Digital image © 2013 The Museum of Modern Art, New York/Scala, Florence.

Sketches may seem a bit old-fashioned but they immediately signal the speculative nature of the story-world he has created. In *Planet as Festival* (1972–1973) Ettore Sottsass adopts a similar but less personal approach. Disillusioned with 1970s hyperconsumer society, he produced a set of simple, slightly naive pencil drawings of fourteen symbolic cities and buildings. They depict

> a utopian land where all of humanity would be free from work and social conditioning. In his futuristic vision goods are free, abundantly

Paul Noble, *Public Toilet*, 1999. Photograph courtesy of Gagosian Gallery. © Paul Noble.

produced, and distributed throughout the globe. Freed from banks, supermarkets, and subways, individuals can "come to know by means of their bodies, their psyche, and their sex, that they are living." Once consciousness has been reawakened, technology would be used to heighten self-awareness, and life would be in harmony with nature.[4]

Their cartoonlike quality invites us to view them as inspirational daydreams rather than hard proposals intended to be realized. Artist Paul Noble also uses drawing to set out his vision for an ever-evolving utopian city. The drawings made with graphite pencil and often wall-sized portray scenes from an imaginary town called *Nobson Newtown*. Although at first they look realistic, on closer inspection all sorts of oddities begin to appear: the buildings are often in the form of three-dimensional letters for instance. They gently push the tradition of visionary architecture into a surreal and fantastical space that, unlike Sottsass's schemes, are free from any overt social or political intent.

Marcel Dzama, *Poor Sacrifices of Our Enmity*, 2007.
Photograph courtesy of David Zwirner, New York/London.

Artist Marcel Dzama shifts emphasis from place and buildings to people
and activities. He uses pen-and-ink illustrations to create what look like
scenes from secret societies and clubs dedicated to strange rituals. The
drawings look vaguely antique and have a fairy-tale quality. Each consists of
people, devices, uniforms, and actions: *Poor Sacrifices of our Enmity, My
Ideas Were Clay,* and *The Hidden, the Unknowable, and the Unthinkable* (all from
2007) evoke alternative logics and different ways of organizing interactions
and defining priorities for everyday life. Yuichi Yokoyama's series of *Manga,*

Yuichi Yokoyama, from his comic *New Engineering* (New York: Picture Box, 2007). Image courtesy of Picture Box.

New Engineering (2004), *Travel* (2006), and *The Garden* (2007) provide glimpses into highly abstract worlds conveyed through the sounds of interactions with the environment and machine operations. There is no dialogue and barely a narrative. Are these the literary dimension of manga, graphic speculations on a constructivist elsewhere?

A more extreme version of this approach is *Codex Seraphinianus* (1981) by Luigi Serafini. A cult book surrounded by mystery, it portrays an imaginary world, in detail, through pencil sketches and text. The text is written in an imaginary language so there is no way of knowing what you are looking at. It is wildly speculative and impenetrable but this is its charm. There are pages showing what look like strange plants, creatures, instruments, landscapes, and technologies. There is very little, if any connection with known science here, just pure celebration of visual imagination. Along similar lines is the animation *Fantastic Planet* (1973) by Rene Laloux, which portrays life on a planet where biotechnology rather than electromechanical systems is the main form of technology.

Luigi Serafini, *Codex Seraphinianus* (Milan: Franco Maria Ricci, 1981).
Image courtesy of the Franco Maria Ricci Collection Milan.

René Laloux, *La planete sauvage* (*Fantastic Planet*), 1973. © Les Films
Armorial—Argos Films.

Whereas we expect sketches to be speculative, the status of detailed drawings can be more confusing, unless they are of something highly fictional, of course. The anatomical features of the Japanese manga monster Gamera and his foes are beautifully detailed in a volume of the Kaijū-Kaijin Daizenshū movie monster book published by Keibunsha in 1972. The "technologies" behind each one's special powers are clearly illustrated and located precisely within its body along with brief explanations of how they might work. They are, of course, impossible but the drawings play a game with us, skillfully crafting the improbable. In *Growth Assembly* (2009), designers Daisy Ginsberg and Sascha Pohflepp present their ideas for growing product parts in

Alexandra Daisy Ginsberg and Sascha Pohflepp, *Growth Assembly*, 2009. Illustrations by Sion Ap Tomos.

bioengineered plants in the style of natural history illustrations (by Sion Ap Tomas). The combination of pencil drawings, cross-sections, and vaguely recognizable mutated plant parts such as thorns, husks, and vines suggesting machine components achieves just the right level of plausibility. At the other end of the spectrum, the detailed drawings of Bel Geddes's design proposal for *Airliner No. 4* (1929) remain speculative due to a very different kind of improbability, economics.

Norman Bel Geddes, *Airliner No. 4, Deck 5*, 1929. Image courtesy of the Edith Lutyens and Norman Bel Geddes Foundation.

Although not exactly illustration, some artists use very subtle post-production techniques to enhance real imagery; for instance, Filip Dujardin's *Fictions* (2007) recombines photographs of existing architectural features and constructions into fictional architecture, with just enough oddness to hold our attention without being ridiculous or completely impossible. They challenge us to decide for ourselves if they are real or not. Dujardin continues the tradition of imaginary architecture using today's tools while overcoming the aesthetic limitations of CGI. Josef Schulz's *Formen* series (2001–2008) of photographs is similar but more abstract. His original photographs of existing industrial and commercial structures and infrastructure are slightly modified to heighten their abstract nature. Both photographers experiment with logic and reality, pushing the limits of what is possible to build in the real world but in a way that leaves doubts. Dujardin's and Schulz's work stand alone and are completely self-explanatory.

Filip Dujardin, Untitled from the series *Fictions*, 2007.

Josef Schulz, *Form No.14*, 2001-2008, from *Formen* series.

The images produced by the Institute of Critical Zoologists are also subtly modified, relying on texts to be fully appreciated. *The Great Pretenders: Description of Some Japanese Phylliidae from the 26th Phylliidae Convention 2009* (2009) documents a fictional annual gathering of enthusiasts who breed camouflage insects to look exactly like their host plants and the plants to look like insects. The outcome is a set of photographs accompanied by pseudoscientific descriptions of how the animal was bred, for example, *Winner 2009 Phylliidae Convention* (2009), Morosus Abe, by Hiroshi Abe:

> [This is] yet another daring combination of Morosus and Crurifolium along with a subtle modification in its food plant with the genes of the celebicum. It contributes to a dynamic interpretation of resemblance, aesthetic sensibilities and one's understanding of mimicry. The presentation is a good appearance, both in the order of a sacrament and as a malefice; it evokes notions of the scientist as a sorcerer and one who is able to bring about a simulation of appearances. (Atsuo Asami, on announcing the 2009 winner)

Institute of Critical Zoologists, *Winner of the Phylliidae Convention 2009*, 2009, from the series *The Great Pretenders*.

With this project, the Institute of Critical Zoologists push the aesthetics of unreality to the limit, and we no longer can even see the product of their speculations; we can just enjoy the idea in all its purity. All these projects speculate in different ways but they all make use of media typically used in fiction—drawings, computer models, and texts. What happens when this approach is applied to objects?

MODEL AESTHETICS

Artist Thomas Demand creates immaculate cardboard sets and props for his photographs that through their stripped-down forms and surface treatment look real, but not quite, or maybe more than real. For us, the quality of objects in his photographs epitomizes the aesthetic potential of models and their ability to straddle multiple realities—fictional and actual. Some designers, including us, also experiment with reduced physical design

Thomas Demand, *Poll*, 2001. Photograph courtesy of Sprueth Magers. © Thomas Demand, VG Bild-Kunst, Bonn/DACS, London.

Dunne & Raby, *Needy Robot*, 2007 from *Technological Dreams No. 1: Robots*, 2007. Photograph by Per Tingleff.

languages devoid of detail. In our *Technological Dreams Series, No. 1: Robots* (2007) we presented some thoughts about alternative emotional interactions with domestic robotics. We did not want people to fuss about functionality so we developed abstract forms with minimal details intended to function as prompts. Sometimes, these objects can end up with a toylike quality,

PostlerFerguson, *Wooden Giants*, 2010.

something we strive hard to avoid. But designers at PostlerFerguson enjoy this, and they seem to take a perverse pleasure in skillfully abstracting hard core engineering objects and elements of infrastructure such as satellites and oil tankers until they sit, perfectly poised, on the border between toy and model. Their goal is to make the "normal" grand and to celebrate technology with a childlike optimism.

In *The MacGuffin Library*[5] (2008), designers Noam Toran, Onkar Kular, and Keith R. Jones started by authoring a series of film synopses that informed a collection of objects (currently numbering eighteen) addressing themes from a range of interests and inspirations: reenactments, Borges and Carver stories, forgeries, urban myths, the defining of high- and low-brow cinema, alternative histories, and the relationship between media and memory. The objects are all rapid prototypes made from one material, black polymer resin. They explore the aesthetics of conceptual objects in the telling of complex stories supported by additional media. Many of the objects combine object typologies, genres, and archetypes. This kind of speculation experiments with the aesthetics of physical fiction as much as the fiction itself—degrees of abstraction, levels of detail, material, form, scale, typology. In some ways it probably relates more to fine art and literary speculation. They go beyond scenarios intended to communicate fictional

realities by bringing a bit of unreality into the everyday. As an interesting aside, they also suggest that distributing conceptual objects might be a more plausible use for 3D printing than the replacement of product components so often cited as an ideal use for this technology.

Noam Toran, Onkar Kular, and Keith R. Jones, *Goebbels's Teapot*, from the series *The MacGuffin Library*, 2008, ongoing. Photograph by Sylvain Deleu. © Noam Toran.

One of the most beautiful recent examples of model aesthetics is El Ultimo Grito's *Imaginary Architectures* (2011). The project consists of glass models of imaginary architectural schemes, semiformed physical "propositions for the social, material and spiritual elements of cities." The objects represent a house, a station, a cinema, an airport, and a love hotel. They are like a physical version of John Hejduk's drawings—imprecise, evocative, metaphorical, sensual anchors for a poetic vision of how a city could be. They are displayed on two wonderfully glossy red and black tables that also serve as their foundations, both as idea and object. These capture the full potential of the aesthetics of unreality through their unabashed celebration of the prop as something coexisting in physical space and in the viewer's imagination at the same moment. Is it a coincidence that the subject is architecture, again?

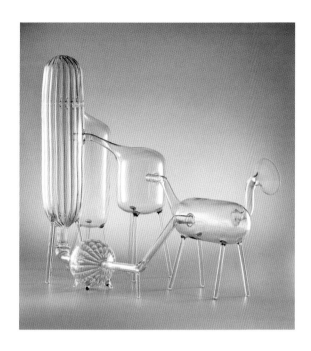

El Ultimo Grito, "Industry,"
2011, from the series
Imaginary Architectures.
Photograph by Andrew
Atkinson.

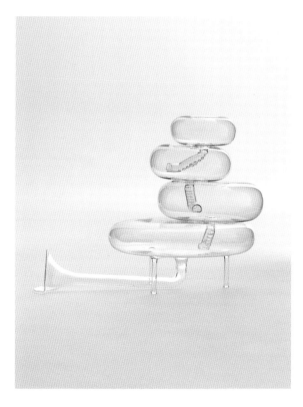

El Ultimo Grito, "House,"
2011, from the series
Imaginary Architectures.
Photograph by Andrew
Atkinson.

These objects all look like props, and we are not surprised when we discover they do not work; in fact, we enjoy the prop status of the object and its celebration of unreality. The next two examples also look, at first glance, like props or models but are fully functional. Dutch industrial designer Marjin Van Der Poll's foam cube *Modular Car* (2002) is designed for customization. In its pure state it is a motorized block of foam that functions as a fully operational car. Although it is meant to be shaped according to the customer's needs, in its raw state it unintentionally provides a striking anti-image of everything car design is today. Joey Ruiter's *Moto Undone* (2011) electric motorcycle takes this further by intentionally stripping away all historical references and treating the motorcycle as a block of highly reflective steel "pure generic transportation" lost in reflections of the environment it silently passes through. With these two designs, prop aesthetics goes full circle and reenters everyday life as a fresh anti-aesthetic that highlights just how narrow today's automobile design vocabulary has become, a by-product of the marketing ethos centered on utility and status that design must serve.

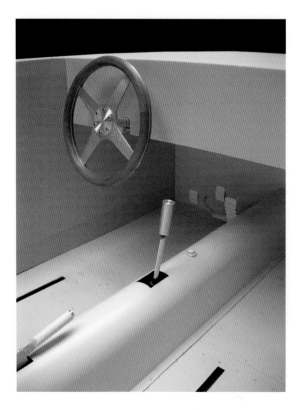

Marijn Van Der Poll, *Dashboard of Modular Car*, 2002.

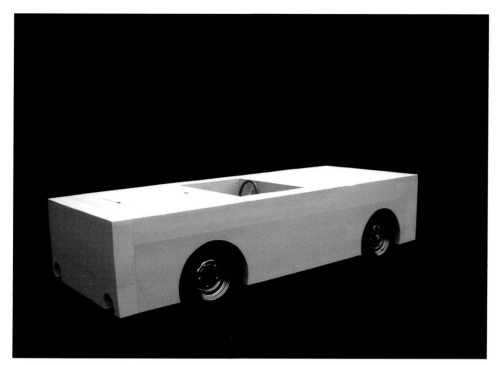

Marijn Van Der Poll, *Modular Car*, 2002.

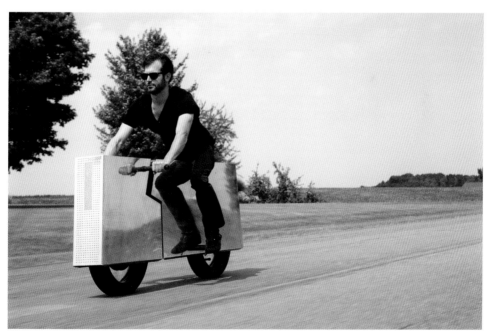

Joey Ruiter, *Moto Undone*, 2011. Photograph by Dean Van Dis.

CHARACTER AS PROP

The physical prop is only one element in the aesthetics of unreality. For us it is definitely the most important one but there are other aspects that we can consider—character, place, and atmosphere.

In a typical design scenario people serve only as idealized users that illustrate how the technology is used. Again, once we move away from realism and, rather than mimicking the world as it is, construct a novel reality, all sorts of fresh possibilities emerge. Probably the best indication of what is possible is Vassilis Zidianakis's *Not a Toy: Fashioning Radical Characters*,[6] which covers a fantastic range of experiments in costume and character design, from fashion to fine art and beyond.

George Lewin and Tim Brown, *Encapsulated Fan*, 2011, from the book *Not a Toy: Radical Character Design in Fashion and Costume* by Vassilis Zidianakis (New York: Pictoplasma, 2011).

The imaginative use of characters as props can convey ideas, values, and priorities very effectively because of our innate ability to read other people's facial expressions, demeanor, gestures, posture, and orientation. By using characters in scenario design we ask viewers to become voyeurs, glimpsing the world of the character and comparing it to their own. Using humans in this way is not so unusual in fine art: Miwa Yanagai and her *Elevator Girls*, Mariko Mori's sci-fi scenes, Cindy Sherman's modifications to herself, and less well-known, Juha Arvid Helinen's striking *Shadow People/Invisible Empire* all speak of alternative worldviews, values, and motivations.

Mariko Mori, *Miko No Inori*, 1996. Video still. © Mariko Mori, Member Artists Rights Society (ARS), New York/DACS 2013.

Juha Arvid Helminen, *Mother*, 2008, from the series *Invisible Empire*

Juha Arvid Helminen, *Black Wedding*, 2008, from the series
Invisible Empire.

Usually, characters are given far more straightforward roles by designers, but that's changing. With *Menstruation Machine: Takashi's Take* (2010) designer Sputniko (aka Hiromi Ozaki) builds a project around Takashi, a man who enjoys dressing up as a woman, but this is not enough, so he builds the menstruation machine to get closer to experiencing what it feels like to be a woman, going beyond visual appearance to experiment with biology. The machine simulates the sensation of the average female menstruation period using a blood dispenser and lower-abdomen-stimulating electrodes. Sputniko, who is also a singer, wrote a pop song about Takashi and produced a music video intended to appeal to teenage girls, her target audience for critical reflection on consumer technologies. When done well, the character not only speaks for itself but also for the values and ethics of the world it inhabits.

Sputniko, *Menstruation Machine: Takashi's Take*, 2010.

One of the most effective recent examples is a viral video released during the build-up to Ridley Scott's film, *Prometheus* (2012). It focuses on David 8, an android produced by the Weyland Industries. Clips of him speaking to camera as he answers probing questions about how he relates to humans are juxtaposed with scenes of him solving puzzles, undergoing psychological tests, and other activities. It is fresh and hints at possible trouble ahead as his answers touch on unexpected ethical and moral issues around how his lack of emotions allows him to do jobs humans could not or would not want to do, and how being able to simulate emotions makes it so much easier for humans to relate to him. In this particular example the product, by "innocently" reflecting on its own capabilities, reminds us just how scary super smart technologies, like itself, may become once they optimize their ability to emotionally manipulate humans.

ATMOSPHERES OF STRANGENESS

In addition to props and characters, there is also the space where whatever happens takes place—from abstract nonplaces set anywhere and nowhere to natural and realistic settings. To find compelling examples here we need to move beyond the concreteness of design, where realism and naturalism dominate, to forms of cultural practice that deal specifically with the creation of atmosphere—fashion and fine art photography, experimental cinema, and conceptual art.

NONPLACES

There is an assumption with speculative work that it is oriented toward the future, but it can simply be somewhere else, a parallel world to our own rather than a possible future. Once you drop the future aspect of speculative work you instantly broaden the scope for aesthetic experimentation and inventive portrayal of alternative realities. One of the most well-known cinematic nonplaces is the vast, white space of George Lucas's *THX 1138* (1971). It is the archetypal future space or nonplace. But white doesn't always have to signal the future. It can also suggest we are watching some kind of experiment, maybe even a thought experiment. In Jørgen Leth's experimental film *The Perfect Human* (1967), a man, woman, and sometimes both interact with basic props to demonstrate fundamental human

Full shot of three chrome police robots with staffs, surrounding Robert Duvall as *THX 1138*. © 1971 Warner Bros. All Rights Reserved.

Jørgen Leth, *The Perfect Human*, 1968. Production still. Photograph by Henning Camre. Photograph courtesy of the Danish Film Institute/The Stills & Posters Archive.

activities such as eating, sleeping, kissing, and dancing. In this film the empty white space is simply a nonplace rather than a representation of the future. In each case the director makes no attempt to construct a detailed world but instead provides a blank canvas, a "white box" onto and into which viewers can project their own thoughts.

TWEAKING THE EVERYDAY

Many corporate future videos are set in a world in which future technologies are inserted into scenes taken from contemporary Western life—slick offices, loft apartments, cafés, busy shopping centers, and so on. The thinking seems to be that this will make the future more believable but it has become a hackneyed worldview. If futures are to be set in the everyday, then designers need to experiment with new ways of tweaking it and engaging the viewer's imagination.

Film design makes good use of hybrids of the everyday and the extraordinary. In *District 9* (2009) by Neil Blomkamp, it is disturbing to see aliens portrayed in a hyperrealistic way in otherwise ordinary settings. Instead of appearing absurd, they are pathetic and downtrodden. They are not at odds with their surroundings at all, but like the space ship they arrived in, they visually blend in. *Children of Men* (2006) by Alfonso Cuarón also takes a gritty approach to the set design. New elements are blended into an existing London; Battersea Bridge, for example, becomes a sentry gate to the Ministry of Art's "Ark of Arts," a fusion of Tate Modern and Battersea Power Station. This treatment creates a powerful atmosphere but it is a little less visually interesting, something the production team on *Children of Men*

openly acknowledged because they aimed for reference rather than invention. Consequently, the police uniforms, weapons, and other state apparatus are what you would expect. *Never Let Me Go* (2010) by Mark Romanek, however, is a melancholic cautionary tale exploring the ethical and psychological consequences of breeding clones as living organ banks for their originals. It is set in a rather underpopulated but vaguely 1970s or 1980s United Kingdom making use of existing stark, concrete public buildings and housing estates to suggest a mildly modernist and melancholic alternative rather than a future United Kingdom. Little anachronistic details such as the clones having to touch an ID card to a reader to enter certain spaces work very well at reminding us that this is not the past. Despite the slightly nostalgic visual treatment, the familiar interaction and blink of an LED says it all.

These films do the opposite of what we argue for in physical fictions. They make us believe even though we know they are not real, which works because they are films and we fully understand the rules before we ever see them. This level of realism applied to speculative design props or the environments they belong to can confuse reality and fiction in unproductive ways. Viewers have different expectations for design than they do for film. Because of this, we believe it is more interesting to explore new aesthetic possibilities for speculative objects that signal their ambiguous status as simultaneously real and unreal.

Highly aestheticized fashion photography is also a rich source of inspiration for the creation of atmosphere. Its images portray extremely stylized and eroticized parallel worlds produced to the highest visual standards. Steven Meisel's *Rehab* and oil spill-inspired photo spreads for *Vogue Italia* July 2007 and August 2010 aestheticize psychological and environmental disaster. Guy Bourdin's 1970s images for *Vogue* and other publications hint at sinister narratives in stripped-down settings such as hotel rooms. They steer our imaginations toward erotically dark scenarios.

CONSTRUCTED UNREALITIES

There is an abundance of invented worlds and environments in cinema, particularly in fantasy, science fiction, and children's genres (e.g., *Charlie and the Chocolate Factory* [2005], *Avatar* [2009], Steven Lisberger's *Tron* [1982], and Joseph Kosinski's 2010 remake *Tron Legacy*). But once you move beyond these genres there are very few films that experiment with constructed spaces as places in themselves, out of time and place. A notable exception is *Cube* (1997) by Vincenzo Natali in which a group of people are

trapped in a minimal, abstracted puzzle environment they must escape from. Constructed spaces like this allow designers to introduce estrangement, gently forcing viewers to make sense of what they are looking at rather than simply recognizing or reading the cues. They shift emphasis from representation to presentation and away from pure entertainment. They are ideal for exploring ideas but less so for entertainment.

Lars von Trier's *Dogville* (2003) is a good example of making the most of a constructed and abstracted set. The film takes place on a vast stage where buildings are represented as drawn plans with crude labels denoting their purpose. Odd props are sparsely distributed throughout the set. Visually, it is very striking, and although some claim it is difficult to watch, it creates a powerful atmosphere. An almost direct application of Bertolt Brecht's principles of alienation to cinema, the extreme set design intentionally makes it difficult to be immersed in the film because the characters, their actions, and words are foregrounded above plot.

But it is in fine art that the most experimental and varied examples can be found. Jasmina Cibic's *Ideologies of Display* (2008) shows constructed highly evocative spaces each occupied by a different animal—barn owl, arctic fox, boas, deer. They are not exactly neutral but neither do they suggest what they are for or mean. John Wood and Paul Harrison's work is nearly always set in constructed, simplified and abstracted spaces. In *10 × 10* (2011) a camera passes from top to bottom of one scene after another suggesting we are looking into offices in a tower block. In each room a person is doing

Jasmina Cibic, *Dama Dama*, from the series *Ideologies of Display*. Photograph courtesy of the artist.

Jasmina Cibic, *Tyto Alba*, from the series *Ideologies of Display*. Photograph courtesy of the artist.

John Wood and Paul Harrison, *10 × 10*, 2011. Courtesy of the artists and Carroll/Fletcher.

something inexplicable involving costumes, props, and graphics. It is as if the contents of each worker's mind has been translated into his or her office cubicle—the usual gray has been reversed to form a stage for imaginative occupation rather than deadening the mind and subduing the imagination.

By moving away from the polar extremes of futurism and naturalism, a world of aesthetic and communicative possibility becomes available for speculative design. But to exploit this freedom, designers will need to accept the fictional nature of design speculations and, rather than trying to convince the viewer that their ideas are "real," learn to enjoy the unreality of speculation and the aesthetic opportunities it creates.

HIDDEN REALITIES

Probably the richest source of inspiration for us is a genre of photography that presents reality as stranger than fiction. They are often institutional or highly functional environments photographed in a way that captures the alien quality of their hidden, alternative logic. They convey a sense of somewhere else, somewhere with very different values to our own, even if

they usually belong to our society. Early examples are photographs of 1960s computer rooms with secretaries and office workers in classic 1960s outfits interacting with, and around, abstract sculpted plastic forms set on grids of fluorescent lighting and tiled floors. These spaces are almost entirely designed around the needs of computers and there is still something beautiful about seeing delicate and fussy human forms set against crisp machine architecture.

During the 2000s, several photographers developed bodies of work focused on the aesthetics of utilitarian but odd environments. The deadpan photography of Lars Tunbjörk's *Alien at the Office*[7] (2004) portrays mundane spaces that seem extraordinary. Yet these alien spaces are where many people spend their working lives. Lynne Cohen's *Occupied Territory*[8] (1987), Taryn Simon's *An American Index of the Modern and Unfamiliar*[9] (2007), and Richard Ross's *Architecture of Authority*[10] (2007) reveal spaces that we know must exist but have no idea how they look. They have a harsh, inhuman quality, stripped down to the absolute essentials, emphasizing their purpose.

Lynne Cohen, *Classroom in a Police School*, 1985, from her book *Occupied Territory* (New York: Aperture, 1987; 2nd ed., 2012).

Lynne Cohen, *Recording Studio*, 1985, from her book *Occupied Territory* (New York: Aperture, 1987; 2nd ed., 2012).

Lucinda Devlin's *The Omega Suites*[11] (1991–1998) provides glimpses into extreme but ghoulish spaces—execution chambers, the places where the state, on its citizens' behalf, takes people's lives. They are clinical, easy-to-maintain, brutally engineered environments designed to achieve one purpose—the humane killing of human beings. They include safety measures, provision for last-minute retrieval, and the need for the event to be witnessed. Mike Mandel and Larry Sultan's *Evidence*[12] (1977) is an early example of conceptual photography—gathered images from the archives of research centers, laboratories, test sites, and industrial facilities, presented without captions or other information. They compel us to interpret what is going on, to project stories and meanings onto them, illustrating that even objective records are rarely neutral.

But why are these hidden realities interesting for the aesthetics of speculation? We think it is because they border on the unreal themselves, and it is very hard to believe many of them are real. Each place or device is

Lucinda Devlin, *Electric Chair*, *Greensville Correctional Facility*, *Jarratt*, *Virginia*, 1991, from the series *The Omega Suites*. © Lucinda Devlin

Mike Mandel and Larry Sultan, *Untitled*, 1977, from their book *Evidence* (Mike Mandel and Larry Sultan, 1977; 2nd ed., New York: Distributed Arts Publishers, 2003). Photograph courtesy of Mike Mandel and the estate of Larry Sultan.

unique or exists in highly limited numbers, and we are unlikely to ever see one for ourselves. They embody extreme values that for some have no place in this world. They seem to belong in a parallel world where extreme aspects of our own world have somehow metamorphosed into whole environments. In some cases, we are shocked to discover they are in fact from our own world. For us, these are the proto-images for an aesthetics of speculation. They suggest a techno-poetic landscape situated somewhere between what we are and what we have the potential to become.

8.
BETWEEN REALITY AND
THE IMPOSSIBLE

Speculative designs depend on dissemination and engagement with a public or expert audience; they are designed to circulate. The usual channels are exhibitions, publications, press, and the Internet. Each channel or medium creates its own issues of accessibility, elitism, populism, sophistication, audience, and so on. This need for dissemination means speculative designs have to be striking but a danger is they end up being little more than visual icons for communicating an idea, in an instant. The best speculative designs do more than communicate; they suggest possible uses, interactions, and behaviors not always obvious at a quick glance.

CONCEPTUAL WINDOW SHOPPERS

So far, the exhibition has been the main platform for us. Although projects might have developed in different contexts, the exhibition serves as a form of reporting space for presenting the results of research and experimentation.

Design exhibitions usually show existing products, survey historical movements, or celebrate heroes and superstars but they could also serve other purposes; they could function as spaces for critical reflection. Collections such as those of the Wellcome Trust, Pitt Rivers Museum, or London Museum hold everyday objects from distant societies, either in time or geography. When we see a strange shoe or ritualistic object we wonder what kind of society must have produced it, how it was structured, what values, beliefs, and dreams motivated it, if it was wealthy or poor. We enact a form of window shopping, trying things out in our minds. It requires imaginative effort but it also provides scope for individual interpretation. If, rather than looking back in time, we presented people with fictional artifacts from alternative versions of our own society or its possible future, would people begin to relate to them in the same way—a sort of speculative material culture, fictional archeology, or imaginary anthropology?

For many designers, there is a natural tendency to view museums and galleries in a negative light as inaccessible and elitist places to show design. But today, there are many different kinds of museums and galleries, each serving different purposes and catering to different audiences—specialist design museums, science museums, national museums, regional art centers, private galleries—each offering very different opportunities for designers and the public.

Early on, we did everything we could to avoid exhibiting work in a white cube and everything it stood for. We showed in shop windows, homes, shopping centers, cafés, gardens. But always, the work became about the space itself, or the context, rather than the ideas we wished to explore. Slowly, we began to view museums and galleries as experimental spaces, test sites, places for reporting back on our experiments and sharing the results, sometimes with designers, sometimes with broader publics. They can complement other media channels, offering more aesthetic, intimate, unmediated, and contemplative forms of engagement with issues and ideas.

Since the early 2000s, the number of channels for disseminating designs through different media has exploded: from exhibitions and magazine reviews to YouTube and vimeo channels, Twitter, personal websites, blogs, and so on. Hiromi Ozaki's *Menstruation Machine: Takashi's Take* was first exhibited in the

RCA degree show in 2010, which had twenty thousand visitors. It was picked up by *Wired* online and after this appeared on many specialized technology and media art blogs where it was discussed and critiqued in some depth. It was extensively tweeted and began to receive major but superficial exposure, often oversimplified and sensationalized. After appearing as an artwork in an exhibition at the Tokyo Museum of Art, it was covered in newspapers, art magazines, books, and catalogs. In 2011 it was shown in the *Talk to Me* exhibition at MoMA as design. In this setting it challenged designers and professionals as much as the public. All this time it also existed as a YouTube video aimed at teenagers.[1] From its first showing at the RCA as a student project it consistently moved from high to low culture, from pop to niche, through art, design, and technology contexts. Throughout the project, the designer made full use of social media such as Twitter and Facebook not only to promote the project but also to seek volunteers, collaborators, and assistance. It's impossible to say where this project sits based on where it has been shown—artwork, design proposal, high culture, pop, teen sensation? It is all these things to different audiences based on where and how they encounter it.

SPECULATIVE WUNDERKAMMER

Positioning a speculative design is always an issue. Many people struggle to know what they are looking at and how they should relate to it—film prop, science fiction, product design, art? This is something we experimented with in an exhibition we curated with Michael John Gorman for the Science Gallery in Dublin in 2009. We used the title, "What If . . ." to frame each exhibit as a question, something to enjoy, a prop for speculating on very specific topics. The exhibition invited visitors to step out of their everyday reality and enjoy engaging with a variety of what-if questions in the form of tangible design proposals.

The exhibition consisted of twenty-nine projects exploring the social, cultural, and ethical implications of different areas of science. Most of the projects were graduating MA projects from the Design Interactions program at the RCA done in consultation with scientists. Questions included, What if human tissue could be used to make objects? What if everyday products contained synthetically produced living components? What if we could evaluate the genetic potential of lovers? What if we could use smell to find the perfect partner? And, what if our emotions could be read by machines? Although aimed very much at adults and almost completely noninteractive, it was a surprising success with schoolchildren and their teachers because it provided an

opportunity to debate issues concerning the science they were learning about in school.

One of the exhibits, *The Cloud Project* (2009) by Catherine Kramer and Zoe Papadopoulou, offered a platform for discussing nanotechnology. The designers were interested in debates surrounding the disposal of products that use nanotechnology and whether nanoparticles are a health hazard in the way asbestos is. Early in the research they discovered that chefs sometimes use liquid nitrogen to make ice cream, which modifies it at a molecular level, affecting the sensation of eating it. For the designers, this was nano ice cream. From this they had the idea of using an ice cream van as a mobile platform for talks and presentations by activists, scientists, and others. During the project they consulted many scientists including Richard Jones, a nanoscientist with an interest in geo-engineering. Together they realized that, in theory at least, clouds could be seeded to make flavored snow based on a modified version of established cloud seeding technology. Out of this the Cloud Project was born, an ice cream van for seeding clouds to produce flavored snow. At this point the technology exceeded what was possible in an MA project, technically and financially, so the cloud-seeding canons were nonworking.

Catherine Kramer and Zoe Papadopoulou, *The Cloud Project*, 2009.

The ice cream van has appeared in several science festivals around the world, each time guests are invited to make presentations while the audience sample different forms of technologically modified ice cream including fizzy carbon dioxide bubbles, liquid nitrogen ice cream, and flavored vapors inhaled rather than eaten. The audience experiences tasty, technologically modified food while listening to and participating in discussions about possible health implications for nanotechnology.

Dunne & Raby, *What If?* 2010-2011, Wellcome Trust Windows, London. Photograph Dunne & Raby.

Using what-if questions was an approach we developed further for the Wellcome Trust Windows in 2010-2011. Here exhibits were selected based on strong visual impact, intrigue, and ability to arouse curiosity in passers-by viewed at different distances—on the foot path, from passing busses, and while waiting at a nearby bus stop. We developed a third variation for the first Beijing International Design Triennial in 2011, which juxtaposed large images and videos with smaller objects displayed on tables. All three exhibitions acted as speculative *Wunderkammer*, cabinets of curiosity on the scale of rooms, presenting the exhibits as imaginary anthropology rather than art or product design.

Dunne & Raby, *What If?* 2010-2011, Wellcome Trust Windows, London.
Photograph Kellenberger-White.

Dunne & Raby, *What If?* Beijing International Design Triennial, 2011.

IMAGINARY INSTITUTIONS

For the *EPSRC Impact!* project (2010) we worked with the EPSRC (Engineering and Physical Sciences Research Council) to match sixteen designers to sixteen research projects they were funding.[2] Projects in the exhibition ranged from renewable energy devices and security technologies to the emerging fields of synthetic biology and quantum computing. Rather than simply focusing on applications for the science research, designers explored the social, ethical, and political implications of the research.

Design Interactions (RCA), *EPSRC Impact!* project and exhibition, 2010. Photograph by Sylvian Deleu.

Despite being in a gallery, the exhibition played down the "white cube" setting and referenced institutional open days. Spread out on tables, visitors could enjoy outcomes from a wide range of strange interdisciplinary research projects. Using tables rather than plinths, low-hanging ceiling lights rather than spotlights, carpeted floors, and painted lower walls the exhibition design alluded to an imaginary research institute. The projects brought a new perspective to the research by offering creative interpretations of these new scientific ideas. In *Phantom Recorder* (2010) by Revital Cohen, a collaboration with Cambridge Centre for Brain Repair, medical research into

improving the interface between a person's nervous system and a prosthetic limb served as the starting point for a more poetic application of medical technology. When a limb is lost the mind often develops a unique phantom sensation. It could be an extension, an addition, or just a replacement. The technology being researched by the Cambridge team could, theoretically, allow for the sensation to be recorded and played back later, allowing the person to retain an imaginary but important sensation. When the prosthetic has been fitted, digital data of the recorded phantom sensation can be transmitted to the implant, allowing the nerves to re-create the sensation of the telescoped phantom hand, the third foot, or the split arm. The project applies research into a serious and difficult practical issue to more poetic needs. It shifts attention away from using medical technologies to fix our bodies to creating entirely new sensations and possibilities.

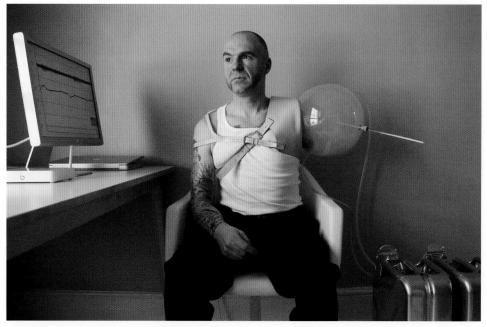

Revital Cohen, *Phantom Recorder*, 2010.

David Benqué, *Fabulous Fabbers*, 2010. Photograph courtesy of EPSRC.

In *Fabulous Fabbers* (2010) David Benqué worked with a group of scientists researching extreme miniaturization and integrated manufacturing similar to rapid prototyping but with built-in electronics. Benqué wondered if this technology might change the meaning of factories. Rather than being situated on the outskirts of towns, once they were free of massive machinery, they would become mobile, almost like festivals of manufacture, traveling from town to town, setting up for a few days then moving on. There would be lavish corporate tents, modest one-man kiosks, and, of course, dodgy vans parked under motorways or in car parks to satisfy the black market.

Superflux (Anab Jain and John Arden), *The 5th Dimensional Camera*, 2010.

If *Fabulous Fabbers* is impossibly utopian, *The 5th Dimensional Camera* (2010) by Anab Jain and John Arden is simply impossible. Working with scientists researching quantum mechanics, they developed a prop for a fictional camera that could take pictures of alternative universes suggested by quantum physics. They explored how people might deal with glimpses into possible parallel lives. Although the most far-fetched of all the designs produced for the exhibition, the prop has been featured in scientific publications as a concrete starting point for discussions about multiverses.

Although the focus of the Impact project was an exhibition, it highlighted different ways design and science could interact: design for science, when design is used to communicate or illustrate the research; design with science, when it is a true collaboration between designer and scientist; design through science, when the designer does some science; and design about science, when issues and implications arising from the research are explored through design, and which is the most interesting approach for us. In several cases designers identified possible negative implications for the scientist's research but because of the trust they had shared felt it would

be wrong to pursue these darker possibilities. For us, the most promising model is when a topic is explored in consultation with several scientists in order to maintain critical distance.

CHAIN REACTIONS

We are very interested in how the relationship between the reality of the here-and-now and the fictional worlds alluded to through props, atmosphere, supporting material, staging, and so on can be managed. In *Between Reality and the Impossible* for the Saint Etienne International Design Biennale in 2010 we were able to explore this thoroughly because we could design everything from the exhibits to the scenography. We started with ideas that we translated into designs then worked with writer Alex Burrett and photographer Jason Evans to develop scenarios through written vignettes and photographs. Everything was given equal importance in the exhibition; photos and texts were presented as three-dimensional objects beside the designs. The intention was to create a chain reaction starting from our initial thoughts and ideas through the objects, Evans's images, and Burrett's texts to be developed further in the imaginations of visitors and reports in other media. It consisted of four projects: *Designs for an Overpopulated Planet, No. 1: Foragers; Stop and Scan; EM Listeners;* and *AfterLife.* We will focus on *Foragers.*[3]

Dunne & Raby, *Between Reality and the Impossible* for the Saint Etienne International Design Biennale, 2010. Photograph by Dunne & Raby.

Dunne & Raby, *Designs for an Overpopulated Planet, No. 1: Foragers*, 2009. Video still.

Dunne & Raby, *Designs for an Overpopulated Planet, No. 1: Foragers*, 2009. Video still.

FORAGERS

The starting point for this project was a brief from Design Indaba exploring the future of farming in the face of food shortages. According to the UN we need to produce 70 percent more food in the next forty years. Yet we continue to overpopulate the planet, use up resources, and ignore all the warning signs. The current situation is completely unsustainable. In 2050 the UN predicts that the world population will be nine billion. Based on the assumption that governments and industry together will not solve the problem, and that groups of people will need to use available knowledge to build their own solutions, bottom-up, we looked at evolutionary processes and molecular technologies[4] to explore how we could take control or our own evolution.

What if it were possible to extract nutritional value from nonhuman foods using a combination of synthetic biology[5] and new digestive devices inspired by the digestive systems of other mammals, birds, fish, and insects? *Foragers* builds on existing groups of people working at the edges of society who may initially appear extreme—guerrilla gardeners, garage biologists, amateur horticulturalists, and foragers. Inspired by these groups we imagined a group of people take their fate into their own hands and begin building devices that function as external digestive systems. They use synthetic biology to create microbial stomach bacteria and mechanical devices to maximize the nutritional value of the urban environment, making up for any shortcomings in the increasingly limited diet available commercially. These people are the new urban foragers.

When developing the objects we explored a range of points of access into the scenario for different people: from a near-future fermenting container worn around the neck to a more extreme prosthetic device that suggested possible transhumanist values. We avoided hyper-realism in the design of the objects and the photography. It was very important that they clearly signaled their unreality so that viewers were aware they were looking at ideas, not products. Rather than the foragers being grungy and dressed in obvious clothing, the photographer suggested they wear outdoor, sporty clothes to challenge expectations of them being organic and anti-technology. Alex's short stories suggested the foragers were far from idealistic, quite pragmatic, and had a complex relationship to mainstream society rather than simply being an isolated cult or commune. These different facets of the project were laid out spatially; objects, photos, and texts were given equal importance so that visitors could wander through the space piecing together their own ideas about *Foragers*.

THE WAY YOU MOVE

I never judge someone by their appearance. I look at the way they move – it runs far deeper. A junkie in a fine suit and Italian leather shoes still fidgets like they're itching for a fix.

One of the first things that struck me about The Foragers was the way they move. Every social group has its idiosyncratic way of moving, with common postures and locomotion styles subconsciously copied by those wanting to belong.

For those who live close to the land, aping is unnecessary. Their physicality is forged by their environments. Arable farmers stride as if permanently crossing freshly ploughed fields. Goat herders display balletic balance gained from negotiating steep mountainsides. Surfers adopt athletic poses: living statues infused with Neptune's might.

Foragers, because they live closer to the land than any group, are the most physically in tune with their surroundings. Although human, if you blur your eyes they are beasts patrolling the Serengeti or wild creatures waltzing through a jungle. I'd previously found our kind clumsy, as if unsteadily making our way on two legs is penance for mastery of the planet. Let me tell you, these committed hobbyists have recaptured the natural grace of the animal kingdom.

Story, Alex Burrett, from *Between Reality and the Impossible*
for the Saint Etienne International Design Biennale, 2010.

Dunne & Raby, from *Designs for an Overpopulated Planet,*
No. 1: Foragers, 2010. Photograph by Jason Evans.

We believe there is tremendous value and potential for design
exhibitions to connect with science, not as a communication medium but for
sparking discussion and debate about possible technological futures. As John
Gray writes in *Endgames*,[6] "Science and technology will serve human needs only
insofar as our societies contain cultures and communities whose self-
understanding is rich enough and deep enough to contain science and
technology—and sometimes to restrain them. Of which late modern society
is this true?"

Dunne & Raby, from *Designs for an Overpopulated Planet, No. 1: Foragers*, 2010. Photograph by Jason Evans.

For us, the exhibition and, in particular, museum exhibitions are ideal places to explore and enrich our "self-understanding." We can build on existing conceptions of what exhibitions are and how they work to develop new approaches and presentation formats. These days, exhibitions are highly accessible. Paraphrasing Jan Boelen, artistic director of Z33, we need to build audiences rather than targeting them.[7] Exhibitions can bring together people interested in how design can engage with the ideas and disciplines shaping our lives, not only in science but also in fields such as politics, law, and economics. We fully agree with Paola Antonelli, senior curator of design at MoMA, when she suggests museums can become laboratories for rethinking society, places for showing not what already exists, but more important, what is yet to exist.

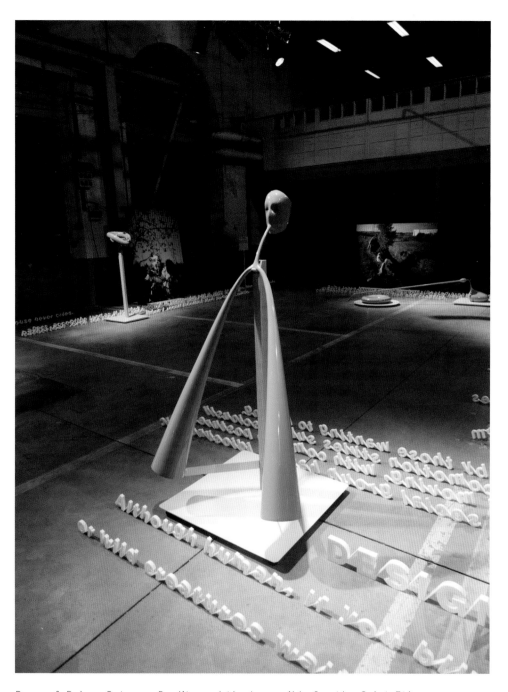

Dunne & Raby, *Between Reality and the Impossible* for the Saint Etienne International Design Biennale, 2010. Photograph by Dunne & Raby.

Dunne & Raby, from *Designs for an Overpopulated Planet, No. 1: Foragers*, 2010. Photograph by Jason Evans.

Dunne & Raby, from *Designs for an Overpopulated Planet*, *No. 1: Foragers*, 2010. Photograph by Jason Evans.

Dunne & Raby, from *Designs for an Overpopulated Planet*, *No. 1: Foragers*, 2010. Photograph by Jason Evans.

9.
♪PECULATIVE EVERYTHING

In *Dream: Re-imaging Progressive Politics in an Age of Fantasy* Stephen Duncombe argues that the radical left has relied too heavily on reason, ignoring the place fantasy and fabricated realities play in our lives. From theme parks to soap operas to brands, whether we like it or not, we now live within a multitude of realities. Duncombe argues that radicals need to embrace this and use it to critical effect, to subvert spectacle for public good and progressive politics. This is particularly challenging for designers because we are usually on the wrong side of spectacle, helping construct ones that encourage people to consume more. Can speculative design take on a social and possibly political role, combining the poetic, critical, and progressive by applying excessively imaginative thinking to seriously large scale issues?

Although operating at a systemic level, large-scale speculative thinking is different from design thinking and social design. Design thinking is concerned with problem solving, and although social design moves away from a purely commercial agenda to deal with more complex human problems, it too focuses on fixing things. Large-scale speculative design contests "official reality"; it is a form of dissent expressed through alternative design proposals. It aims to be inspirational, infectious, and catalytic, zooming out and stepping back to address values and ethics. It strives to overcome the invisible wall separating dreams and imagination from everyday life, blurring distinctions between the "real" real and the "unreal" real. The former exists in the here-and-now, whereas the latter lies behind glass screens, within the pages of books, and locked in people's imaginations. Design speculations can give form to the multiverse of worlds our world could be. Whereas it is accepted that the present is caused by the past it is also possible to think of it being shaped by the future, by our hopes and dreams for tomorrow.

FREE AGENTS

Change can happen in a number of ways:[1] propaganda, semiotic and subconscious communication, persuasion and argument, art, terrorism, social engineering, guilt, social pressure, changing lifestyles, legislation, punishment, taxation, and individual action. Design can be combined with any of these but it is the last one—individual action—that we value most. We believe change starts with the individual and that the individual needs to be presented with many options to form an opinion.

When design is discussed in relation to change, the notion of "nudge"[2] often surfaces. The suggestion is that design can modify our behavior by nudging us to make choices that someone, usually a client organization, would like us to make. To encourage schoolchildren to eat more healthily, for example, junk food might be displayed on lower shelves in a shop and healthy food would be placed at eye level. Stanford-based psychologist B. J Fogg has worked in this area since the early 1990s, calling it *captology*.[3] His focus is on the overlap between persuasion and computers, usually applied to small-scale interactions rather than social change. But once it moves beyond interactions with technology to the social or mass scale, it can feel more like social engineering. This is one of the difficulties we have with design thinking applied by service designers to public service projects. It can be used to modify our behavior in a slightly underhanded way. For example, on the UK Government's Cabinet Office website, it says the following: "The Behavioural Insights Team was set up in July 2010 with a remit to find innovative ways of

encouraging, enabling and supporting people to make better choices for themselves."[4]

We believe that our behavior does need to change, but it should be up to either individuals to make changes in their behavior (for example, in health and exercise) or the government to ban some kinds of behavior (such as smoking, which effects everyone, not just the smoker). At both extremes the rationale for change is explicit. Design can play a role in highlighting what might happen if behavior does not change, what can be achieved if it does, or simply communicating what needs to change and how. Of course this is an idealistic view of human nature that does not allow for poor education or other factors, but we prefer to base our design approach on this ideal rather than assume people have little or no control over the choices they make. We view people as free agents, not necessarily rational, but free to make up their own minds. As consumers we can choose not to buy products produced by companies or countries whose values we disagree with; as citizens we can vote, demonstrate, protest, and in extreme cases, riot.

As Erik Olin Wright points out in *Envisioning Real Utopias*, "the actual limits of what is achievable depend in part on the beliefs people hold about what sorts of alternatives are viable."[5] For us, this is where speculative design steps in. It can make a whole range of viable and not so viable possibilities tangible and available for consideration. Wright continues: "Claims about social limits of possibility are different from [these] claims about physical and biological limits, for in the social case the beliefs people hold about limits systematically affect what is possible. Developing systematic, compelling accounts of viable alternatives to existing social structures and institutions of power and privilege, therefore, is one component of the social process through which the social limits on achievable alternatives can themselves be changed."[6]

We believe that even nonviable alternatives, as long as they are imaginative, are valuable and serve as inspiration to imagine one's own alternatives. Speculative design can be a catalyst for this: it can inspire imagination and a feeling that, if not exactly anything, more is definitely possible. Speculative design contributes to the reimagining not only of reality itself but also our relationship to reality. But for this to happen, we need to move beyond speculative design, to speculative everything—generating a multitude of worldviews, ideologies, and possibilities. The way the world is follows on from how we think; the ideas inside our heads shape the world out there. If our values, mental models, and ethics change, then the world that flows from that worldview will be different, and we hope better.

Writing about the value of literature in *Such Stuff as Dreams*, Keith Oatley states, "In art we experience the emotion, but with it the possibility of something else, too. The way we see the world can change, and we ourselves can change. Art is not simply taking a ride on preoccupations or prejudices, using a schema that runs as usual. Art enables us to experience some emotions in contexts that we would not ordinarily encounter, and to think of ourselves in ways that usually we do not."[7]

Can design achieve this, too, if it is decoupled from narrow commercial agendas? We think so. By embodying ideas, ideals, and ethics in speculative proposals design can play a significant role in broadening our conception of what is possible.

ONE MILLION LITTLE UTOPIAS

> Maybe each human being lives in a unique world, a private world, a world different from those inhabited and experienced by all other humans. And that led me wonder, if reality differs from person to person, can we speak of reality singular, or shouldn't we really be talking about plural realities? And if there are plural realities, are some more true (more real) than others?[8]

Philip K. Dick wrote this in 1974 just as mass media was affecting reality and blurring the boundaries between inner and outer worlds. We believe, like Philip K. Dick does, that there is no longer one reality, but seven billion different ones. The challenge is to give them form. The individualistic approach, although associated with right-leaning liberalism, is also an impetus for highly individualistic micromodifications to reality, usually to satisfy some desire that official culture is unable to meet, such as unconventional political views or specialist sexual fantasies and fetishes. Timothy Archibald's *Sex Machines: Photographs and Interviews*[9] (2005) is a wonderful example of people tinkering with the world around them to accommodate their desires. It is a shame the machines are so phallic and mechanical but nonetheless the technical ingenuity is fascinating. *Image Club* (2003) by Tsuzuki Kyoichi is a photographic document of environments, props, and services designed to facilitate sexual fantasies. These are more conceptual than Archibald's devices because they work on the mind rather than the body. They are usually one-off environments set up to aid sexual fantasies, specially constructed parallel worlds where the usual rules governing human interactions are suspended. No matter what the setting—tube carriage, classroom, forest, workplace—there is always a bed. Unlike sex machines, the environments are not well crafted; there is just enough detail to transport the client's imagination.

Timothy Archibald, *Dwayne with the Two to Tango
Machine*, 2004, from his book *Sex Machines:
Photographs and Interviews* (Los Angeles: Daniel 13/
Process Media, 2005). Photograph by Timothy
Archibald.

The construction of one-off micro-utopias built around the desires of a
single person or small group is something artists have explored, too.[10] Atelier
Van Lieshout has experimented with fantasy environments within an artistic
context, although it is never clear how much is about satisfying his own
fantasies and how much is commentary. His early work consisted of rooms and
environments designed to make orgies more comfortable and easy to run. In
2001 he took over an unused plot in the Rotterdam Harbor area, called it
AVL-ville, and sought to have it recognized as a free state. Due to a throw-
away remark in a lecture, AVL-ville attracted unwanted attention from
inspectors and the police, creating vast amounts of bureaucracy. Eventually
Van Lieshout decided to close AVL-ville so that he could concentrate on
producing art works rather than dealing with officials.

Perhaps the most successful form of micro-utopia is the intentional community, or its more extreme form, the cult. Our favorite is Panawave. Based in Japan, one of their core beliefs is the harmfulness of electromagnetic radiation, and they go to great lengths to avoid it. Believing that white protects them from harmful rays they cover their vehicles, camps, and personal objects with white fabric. They travel in convoys seeking parts of Japan with low levels of electromagnetic pollution. They first came to public attention in the early 2000s during a standoff with police after causing a huge traffic jam while searching for a safe haven. Their use of white fabric, tape, and uniforms to protect themselves and their leader from electromagnetic radiation led to many striking images of their temporary camp circulating in the media.

Whether you view them as charming eccentrics or restless idealists, the creators and users of these devices and environments defy the strict rules Western societies place on mixing different kinds of reality. They inspire us to question why the real is "real" and the unreal is not; who decides? Is it market forces, evil genius, chance, technology, or secret elites?

These projects celebrate people's ability to make their own imaginative worldviews tangible. The days of designers dreaming on behalf of everyone have passed but designers can still facilitate a dreaming process that unlocks people's imaginations. Micro-utopias like these serve as inspiration, encouraging not mega-utopias defined from the top down but seven billion little utopias emerging from the bottom up, facilitated by, not determined by, design.

BIG DESIGN: THINKING THE UNTHINKABLE

Although inspirational, these externalized dreams and fantasies are still quite modest in scale—a disadvantage of working outside official systems, semi-underground, or in the privacy of one's home or studio. There are also dreamers working within the system of industry, funding organizations, universities, and markets, who are attempting to imagine a better world for all, even if sometimes they might reflect their own personal obsessions.

Buckminster Fuller would usually spring to mind as an example of this but his visions are a little too technological and rational for us. Norman Bel Geddes, however, mixed modern, everyday technologies with dreams, fantasy, and the irrational. He went well beyond problem solving, using design to give form to dreams. In his *Highways & Horizons* exhibit, better known as *Futurama,* for the General Motors pavilion in the 1939 New York World's Fair, Bel Geddes designed an environment of large-scale models featuring a national

network of expressways, illustrating its implications and possibilities twenty years into the future. For example, by speeding up traffic flow and reducing journey times, commuters could live further away from city centers, which in turn affects the workable size of cities. At the time *Futurama* was viewed very much as an America of the near future, a realizable dream rather than a fantasy. Other projects were closer to fantasy. His *Airliner Number 4* (1929) was a nine-story, amphibian plane twice the size of a Boeing 747 jumbo jet. It had room for deck games, an orchestra, a gymnasium, a solarium, airplane hangars, and could sleep 606 passengers. Bel Geddes intended it to be built and flown between Chicago and London, but sadly, was unable to raise the necessary funding.

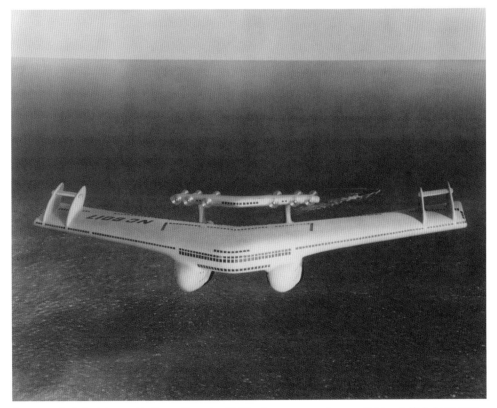

Norman Bel Geddes, *Airliner No. 4*, 1929. Image courtesy of the Edith Lutyens and Norman Bel Geddes Foundation.

In the shadowlands of big thinking is the RAND Corporation and Herman Kahn. The RAND Corporation developed many of the techniques used today for scenario building.[11] Kahn, who coined the phrase "thinking the unthinkable," more than many, really did think the unthinkable. At one point he reconceptualized the practicalities of nuclear war by thinking through the aftermath in a rational way: what the costs would be and how America could rebuild itself after a nuclear war. This alarmed many people because it shifted the possibility of a nuclear war from the realm of the completely unimaginable to something much closer to everyday life, even if at an extraordinarily high human and planetary cost.

Interview with Herman Kahn, May 11, 1965. Photograph by Thomas J. O'Halloran. Photograph courtesy of Library of Congress Prints and Photographs Division Washington, DC 20540 USA.

From the post-war years to the 1970s, rather than only being put to work solving problems, technology was also used to ignite excessive imaginings and audacious dreams for how life could be, and not just on earth; there were many proposals for space colonies, too. This was not limited to Europe and the United States. During the same period the Soviet Union developed many technologies embodying the dreams, values, and ideals of a parallel communist world. The *Ekranoplan* was a heroic attempt to create a novel plane that

skimmed the surface of the water using ground effect to fly at great speed delivering vast numbers of marines to battle zones separated by large lakes. Soviet technology, developed outside Western ideals and contexts, shows that technology is as much an embodiment of ideology, politics, and culture as science. One can't help but wonder if ideology[12] is at the source of true innovation in the sense that new ideas and thinking come from new and different ways of viewing the world.

The Lun-class Ekranoplan, *Kaspiysk*, 2009. Photograph by Igor Kolokolov.

The Lun-class Ekranoplan, *Kaspiysk*, 2009. Photograph by Igor Kolokolov.

With a few governmental exceptions, such as DARPA—where some of the most imaginative, boldest, and admirably ridiculous thinking is to be found, invisibility cloaks and holes in time, for example—and commercial exceptions such as Google's X Lab, which is currently working on space elevators and asteroid mining, it feels today as if the era of big ideas and fantastic dreams has passed. Much of today's dreaming around technology is shaped by military priorities or a short-term, market-led view of the world based on standardized consumer dreams and desires. And bold visions put forward by architects such as *Terreform ONE* and *BIG* (Bjarke Ingels Group) don't seem to include the underlying alternative worldviews and ideology of earlier big thinkers. Even the dream of space travel has been hypercommodified, becoming just another commercial offer, something artist Joseph Popper addresses in his project *One-Way Ticket* (2012): a proposal to send one person on a voyage into deep space from which he or she would never return. He made a short film of episodes transmitted from the spacecraft at key moments, suggesting unique psychological phenomena that might occur on a one-way trip into deep space. But who would this astronaut be—a volunteer with a terminal illness, a lifer opting to die for science rather than in prison? Although in this project, space travel is being considered once again, it is anything but romantic. The messy human details—ethical, psychological, and physical—are right in the foreground.

Planetary Resources Inc., *Asteroid Mining*, 2012. Swarms of low-cost robotic spacecraft will enable extraction of resources from near-earth asteroids.

Joseph Popper, *The One-Way Ticket*, 2012. Film still.

SOCIAL DREAMING

The social dimension to big thinking has vanished, replaced by science, technology, and logic. Where can new worldviews be developed, how can they be used to generate new visions for everyday life? Think tanks are supposed to do this, but as Adam Curtis writes,

> the question is whether most Think Tanks may actually be preventing people thinking of new visions of how society could be organised—and made fairer and freer. That in reality they have become the armoured shell that surrounds all politics, constantly setting the agenda through their PR operations which they then feed to the press, and that prevents genuinely new ideas breaking through.[13]

Other organizations such as The Seasteading Institute try to develop new possibilities within existing systems by identifying legal loopholes for establishing new economic zones. One of their proposals is to moor a ship just off the Californian coast as a base for high-skilled workers who want to participate in Silicon Valley but are unable to secure work visas.[14] Although we like the legal cleverness of this proposal we are not so convinced by the ends it serves. Bruce Mau's *Massive Change Project* (2006) has as its motto, "It's not about the world of design. It's about the design of the world."

A fantastic starting point, the project "explores the legacy and potential, the promise and power of design in improving the welfare of humanity."[15] But again, weighed down by the gravity of reality, the focus is on problem solving. The website for the Centre for Design and Geopolitics based at the University of California, San Diego, says it views California as a design problem, which nicely captures the scale, ambition, and spirit of their mission to redesign geopolitics rather than trying to solve problems within existing political structures.[16] This is much closer to our interest in providing new perspectives, sparking fresh thinking, and broadening the imaginative scope of thinking in this area.

But of course writers have been doing this for a long time, and many utopias (and dystopias) are forms of political fiction. One of the first by a designer is William Morris's *News from Nowhere* in 1890, which set out his vision for an alternative England set in a utopian future.[17] Since 2000 there has been a spate of design books exploring ideas around alternative models of everyday life from economics to language. Architect Ben Nicolson's *The World: Who Wants It* (2004) sets out a new world order funded by the United States that addresses some of the world's more complex problems in imaginatively impractical ways. More recently, Sternberg Press's *Solution Series* invites authors to reimagine existing countries. In *Solution 239-246: Finland: The Welfare Game* (2011), Martti Kalliala, Jenna Sutela, and Tuomas Toivonen set out eight and one-half ideas for a new Finland including hosting the world's nuclear waste and sending its young around the world as gap-year ambassadors of Finnish mythology to boost the tourist trade. In *Solution 11-167: The Book of Scotlands (Every Lie Creates a Parallel World. The World in Which It Is True)*, Momus describes hundreds of Scotlands, all fictional, some more bizarre than others. The series applies imagination to issues ranging from national identity and mythology to contemporary social and economic problems in ways that inspire the reader to speculate and imagine, too. Although they do not offer design proposals they do provide fascinating briefs.

Can design operate in this way, borrowing methods from literature and art and applying them to the real world as thought experiments? The design collective Metahaven has developed a sustained critique of neoliberalism through a series of uncorporate identities for imaginary corporate-government states by subverting branding and corporate identity strategies from a graphic design perspective.[18] Their *Facestate* (2011) installation for *Graphic Design: Now in Production* at the Walker Art Center explored parallels between social software and the state: "It is about politicians hailing the entrepreneurship of Mark Zuckerberg, about the neoliberal dream of minimal

SOLUTION 11-167
THE BOOK OF
SCOTLANDS
MOMUS

EVERY
LIE CREATES
A PARALLEL
WORLD.
THE WORLD
IN WHICH IT
IS TRUE.

S11-167 Sternberg Press

SOLUTION 239-246
FINLAND
THE WELFARE GAME
MARTTI KALLIALA
WITH JENNA SUTELA AND TUOMAS TOIVONEN

the people
-ful
KANSALLINEN PROJEKTI
project
national

S239-246 Sternberg Press

SOLUTION 214-238
THE BOOK OF JAPANS
MOMUS

THINGS
ARE
CONSPICUOUS
IN THEIR
ABSENCE.

S214-238 Sternberg Press

SOLUTION 186-195
DUBAI DEMOCRACY
INGO NIERMANN

WHERE
DESERT
DREAMS
COME
TRUE

S186-195 Sternberg Press

SOLUTION 196-213
UNITED STATES OF
PALESTINE-ISRAEL
JOSHUA SIMON (ED.)

we

them

S196-213 Sternberg Press

SOLUTION 1-10
UMBAULAND
INGO NIERMANN

[BENEFIT
—
COST]
COMMITMENT
=
EFFICIENCY

S1-10 Sternberg Press

Sternberg Press, Berlin, *Solution Series Cover Artwork*, 2008, ongoing.
Designed by ZAK Group, London.

government interference, about the governance of social networks, about
face recognition, about debt, about the future of money and currency in
social networks, and about the dream of total participation."[19] Metahaven
combines extensive research with the setting out of fictional corporate
government hybrids through design.

Whereas Melahaven goes straight to the heart of the system producing political fictions expressed through corporate brand and identities, we are interested in exploring how the consequences of different political systems might affect things such as food production, transport, energy, and work, ideally with surprising and unexpected outcomes or how different political systems could create very different experiences of everyday life. *Eneropa* (2010) by Rem Koolhaas's think tank AMO is part of a study for the European Climate Foundation called *Roadmap 2050* looking at energy strategies for Europe. The main idea is to run Europe on a shared grid of renewable energy. Although the project consists of a substantial report, it is one image that catches our attention, a fictional map of an alternative Europe with regions renamed according to their main source of renewable energy—Isles of Winds, Tidal States, Solaria, Geothermalia, Biomassburg, and so on. It is a simple image for a complex idea but it is effective and can easily facilitate debate and discussion about shifting European identities due to shared energy sources among the public, policy makers, and the energy industry.

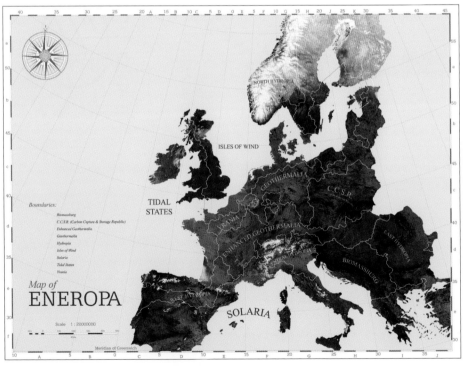

Rem Koolhaas, AMO, *Roadmap 2050 Eneropa*, 2010. © OMA.

THE UNITED MICRO-KINGDOMS: A THOUGHT EXPERIMENT[20]

Inspired by all this big thinking we decided to try a design experiment to take the literary imagination behind the *Sternberg Solution* series, or *The World, Who Wants It,* and combine it with more concrete design speculations.

After finding the wonderfully titled *The Beginner's Guide to Nation-Building* published by the RAND Corporation in 2007,[21] we began to wonder how nations were built and if states could be designed. Architects have long developed master plans for cities and regions. Could we talk about big ideas through small things? The Design Museum in London invited us to try.

It is common in the design of technology products and services to start with personas, then develop scenarios, all within existing reality. Here, we wanted to zoom out and start with new realities (ways of organizing everyday life through alternative beliefs, values, priorities, and ideology) then develop scenarios and possibly personas to bring it to life, to "tell worlds rather than stories," as Bruce Sterling so aptly puts it.[22] By presenting the viewer with design proposals for objects, would they imagine the world the designs belong to and move from the specific to the general? This is very different from other world-making activities such as cinema and game design in which the world itself is shown, and even architecture, which usually presents an overview from which the viewer has to imagine the specific.

SO YOU WANT TO DESIGN A STATE?[23]

We explored different ways of constructing alternative ideological systems and came across a type of chart used to illustrate different political positions. There are several variations but they typically have four points on two axes: left, right, authoritarian, and libertarian. The left-right axis usually defines economic freedom whereas the libertarian-authoritarian axis defines personal freedom.[24] Based on these, we began to explore an alternative England divided into four regions with different ideologies. We used the United Kingdom because a completely imaginary place would lack any connection to the world we currently occupy.[25] We hoped calling them micro-kingdoms rather than micro-states or micro-nations would suggest they are more like fables or tales based on imagination rather than hard scenarios based on analysis and reason—somewhere between sci-fi and foresight.

Not wanting to visualize the world in a cinematic way or use pieces of evidence such as flags, documents, and other bits of everyday life but instead to present it through one type of object that would allow for comparisons between the different micro-kingdoms, we needed to find an appropriate vehicle. We chose transport. Transport involves not only

technology and products but also infrastructure; we could think big but present our thinking at the more concrete scale of vehicles. Each vehicle would embody different ideologies, values, priorities, and belief systems—essentially alternative worldviews.

Many assume that when fossil fuels run out Western politics will continue and simply apply itself to whatever new form of energy replaces fossil fuels. This is not necessarily the case. Western political systems are intricately entangled with fossil fuels. As Timothy Mitchell writes in *Hydrocarbon Utopia*, "The leading industrialized countries are also oil states. Without the energy they derive from oil, their current forms of political and economic life would not exist. Their citizens have developed ways of eating, traveling, housing themselves, and consuming other goods and services that require very large amounts of energy from oil and other fossil fuels."[26]

By working with vehicles we could playfully explore new combinations of political systems and energy sources in a post-fossil-fuel England divided into four super shires, each experimenting with different forms of energy, economics, politics, and ideology. Each one offers an alternative to a fossil fuel-dependent world and is designed to expose trade-offs: convenience versus control, individual freedom versus hardship, unlimited energy versus a limited population. Vehicles are also highly charged symbols of freedom and individuality, which would allow us to explore how new dreams might evolve for each micro-kingdom. Each vehicle would stand for something more than itself, not exactly a metaphor, more a synecdoche.

Next we sketched out four regions and four combinations of technology and ideology: communism and nuclear energy, social democracy and biotechnology, neoliberalism and digital technology, and anarchy and self-experimentation.

The project narrative is as follows: In an effort to reinvent itself for the twenty-first century, England devolved into four supershires inhabited by digitarians, bioliberals, anarcho-evolutionists, and communo-nuclearists. Each county became an experimental zone free to develop its own form of governance, economy, and lifestyle. England became a deregulated laboratory for competing social, ideological, and economic models. Its aim was to discover through experimentation the best social, political, and economic structure to ensure its existence in the new postcrash world order—a sort of preapocalyptic experiment designed to avoid the thing itself, which increasingly, seemed inevitable.

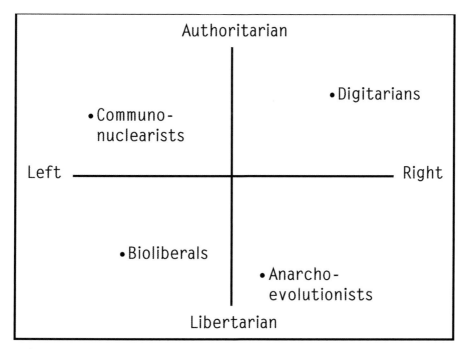

Political Chart. Illustration by Kellenberger-White.

DIGITARIANS

As their name suggests, digitarians depend on digital technology and all its implicit totalitarianism—tagging, metrics, total surveillance, tracking, data logging, and 100 percent transparency. Their society is organized entirely by market forces; citizen and consumer are the same. For them, nature is there to be used up as necessary. They are governed by technocrats, or algorithms—no one is entirely sure or cares—as long as everything runs smoothly and people are presented with choices, even if illusionary. It is the most dystopian yet familiar of all the micro-kingdoms.

Their main form of transport is the digicar, a development of electric self-drive cars being pioneered today by companies such as Google.[27] The car has evolved from being a vehicle for navigating space and time, to being an interface for navigating tariffs and markets. Every square meter of road surface and every millisecond of access, at any moment, is monetized and optimized. Today, self-drive cars are presented as social spaces for relaxing commutes, but digicars are closer to economy airlines, offering the most basic but humane experience. It is essentially an appliance, or computer, constantly calculating the best, most economic route. The dashboard doesn't

Dunne & Raby, *Digicars*, from *United Micro Kingdoms*, 2013. Computer model by Graeme Findlay.

have speed or rev counters but readouts for money versus time. Those on pay-as-you-go contracts rather than prepaid ones must calculate in real time: "move into the blue lane for 34 minutes to save £15.48 on your current trip"—no mean feat.

These highly responsive, tailored pricing systems, ostensibly to meet individual needs and optimize road access, are really designed to maximize profit. The roads are still owned by the state but companies bulk buy access and offer it to their customers in the same way telecom companies today manage the radio spectrum.

The digicar does allow for expression of status though. Power and speed are replaced by footprint and privacy—how much space you take up and whether it is shared or not. There are priority tariffs, and options for sharing journeys while maintaining privacy. Tariffs are calculated according to a P5 index: price, pace, proxemics, priority, and privacy. There is also a sleeper option in which the traveler is put to sleep and sent on his or her way with all vital functions remotely monitored.

As digicars are computer managed and controlled, they rarely crash or collide, consequently their designs are simple and utilitarian. They resemble appliances: cute, charming, basic. The digicar stands for all that is wrong with today's services. It is the ideal solution for a society that promotes freedom of choice and entitlement above all else, even in the face of ever-diminishing resources, such as road space.

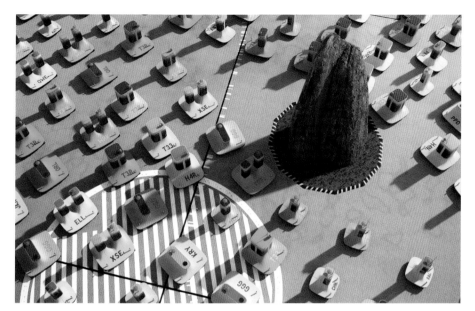

Dunne & Raby, *Digicars with Rock*, from *United Micro Kingdoms*, *2013*. CGI by Tommaso Lanza.

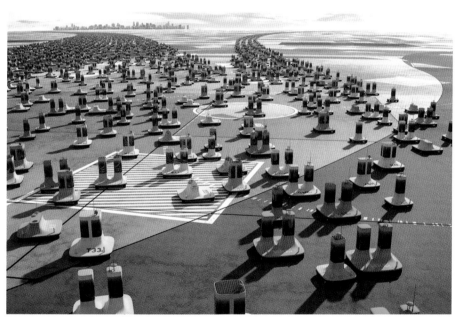

Dunne & Raby, *Digicars*, from *United Micro Kingdoms*, *2013*. CGI by Tommaso Lanza.

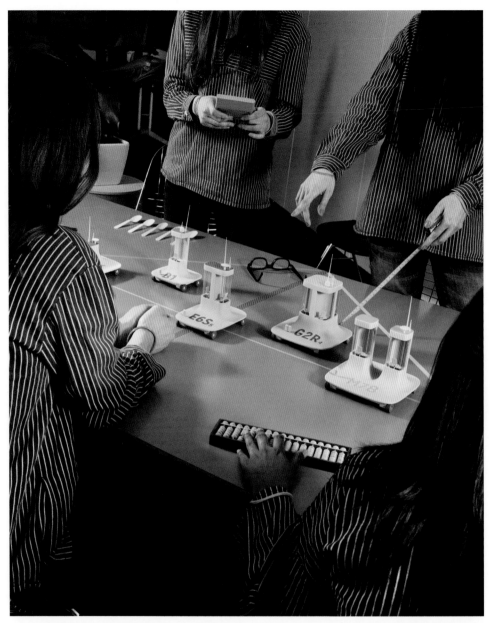

Dunne & Raby, *Digicars*, from *United Micro Kingdoms*, 2013. Photograph by Jason Evans.

As one might expect, Digiland is made of vast, never-ending planes of tarmac: a cross between airport runways, sports fields, and car parks, dense with markings no human can decode—a landscape exclusively for machines. Clean electric cars mean distinctions between inside and outside are minimized; roads flow through houses, shops, and factories.

Digitarians are already among us and their mind-set is shaping the world around us. How far are we prepared to let it spread?

Dunne & Raby, *Digiland*, from *United Micro Kingdoms, 2013*. Video still from an animation by Nicolas Myers.

BIOLIBERALS

Whereas digitarians use digital technology to manage supply and demand of diminishing resources and to create an illusion of unlimited access for all, the bioliberals who are social democrats, pursue biotechnology, and with it, new values.[28] They, too, want freedom and choice for all but they want it to last. Bioliberals live in a world in which the hype of synthetic biology has come true and delivered on its promises. Massive government investment in biotechnology has led to a society in symbiosis with the natural world. Biology is at the center of their worldview, giving rise to a radically different

Dunne & Raby, *Biocar*, from *United Micro Kingdoms*, 2013.
Photograph by Jason Evans.

Dunne & Raby, *Biocars*, from *United Micro Kingdoms*, 2013.

technological landscape to our own. Nature is enhanced to meet growing human needs but people also adjust their needs to match available resources. Each person produces his or her own energy according to their needs. Bioliberals are essentially farmers, cooks, and gardeners. Not just of plants and food, but of products too. Gardens, kitchens, and farms replace factories and workshops.

Bioliberals regard the use of huge amounts of energy to overcome gravity and wind resistance to be counterproductive and primitive. Faster is no longer better. People travel in extremely light organically grown, biofueled vehicles, each customized to its owner's dimensions and needs.

Fossil fuel and the combustion engine is an impressive combination that dominates and shapes the Western world today. Whole dreams of freedom have grown from it. But it is unsustainable on so many fronts. What if we looked at transport through a biotechnological lens: what would a true biocar be like? Ones we have seen don't look so different. Current research into biofuels such as algae aims to replace petrol so that little has to change.

If we were to fully embrace an alternative technology like biotechnology, society and its infrastructure would have to substantially change. Is it futile to even consider designing a biocar from scratch? Based on current values it seems to make no sense at all, but perhaps that's the point.

The bioliberal car combines two technologies: anaerobic digesters that produce gas and fuel cells that use the gas to produce electricity. Bags of uncompressed gas cannot compete with the efficiency of fossil fuels, a fuel based on millions of years of preparation compared to one that takes hours or days. The resulting cars are slow, bulky, messy, smelly, and made of skin, bone, and muscle, not literally but in abstracted forms. Wheels, for example, are powered individually using jellylike artificial muscles.[29]

We wanted their vehicles to be nonaerodynamic, big and unwieldy, suggesting that a very different logic informs their design, one that is absurd from today's perspective. But that's the point. This is a visual expression of what needs to change if we are to develop new ways of existing based on new values.

ANARCHO-EVOLUTIONISTS

The anarcho-evolutionists abandon most technologies, or at least stop developing them, and concentrate on using science to maximize their own capabilities through training, DIY biohacking, and self-experimentation. They believe that humans should modify themselves to exist within the limits of the planet rather than modifying the planet to meet their ever-growing needs. There is a high number of trans- and posthumanists among anarcho-evolutionists. They essentially take evolution into their own hands. Very little is regulated; citizens can do as they please as long as it doesn't harm anyone else.

The anarcho-evolutionists have little trust in government and tend to self-organize. Citizen's rights are based only on trust and agreement between individuals and groups. They are the opposite of digitarians. The human is at the center of their world, along with freedom from being told what to do.

The anarcho-evolutionist's world is a world without cars. Their transport is either human, wind, or genetically modified animal powered. The vehicles are designed around the principle of organization without hierarchy and embody their social order and values. Sociality and cooperation are more important than speed and competitiveness. A misconception about anarchy is that it is chaotic; in fact, anarchism depends on a high degree of

Dunne & Raby, *Very Large Bike (VLB)*, from *United Micro Kingdoms*, 2013. Photography by Jason Evans.

organization. It's just that it is flexible, fluid, and nonhierarchical. The anarcho-evolutionists travel in groups, each doing what they are best at, and each is responsible for a bit of the vehicle. The vehicles reflect their social order and values. The bike is not as many would expect, a collection of independent bikes, but a very large bike (VLB) designed for traveling long distances in groups, pooling effort and resources. Traveling on abandoned motorways, it is gently steered by leaning, each person knowing from experience and practice just how much is required of them. The elderly, young, and weak are carried along by the others and are experts at singing and telling stories to entertain and motivate the cyclists.

The family or clan is the most important social unit. Families evolve around particular forms of transport using a combination of genetic modification, training, and the passing down of knowledge and skills from generation to generation. A distinctive physique is associated with each clan and is a matter of pride. Cyclists have well-developed thighs, balloonists are tall and willowy, and so on. As well as modifying themselves, anarcho-evolutionists have developed new forms of animal to satisfy their needs: the hox is a mix of horse and ox, a hybrid animal bred to move heavy loads and pull carriages, while the pitsky is a combination of pit bull terrier and husky, designed for pulling smaller loads and personal protection.

Dunne & Raby, *Balloonist, Cyclist, Hox, and Pitsky*, from *United Micro Kingdoms*, 2013. Photograph by Jason Evans.

COMMUNO-NUCLEARISTS

The communo-nuclearist society is a no-growth, limited population experiment. They live on a three-kilometer-long, nuclear-powered, mobile landscape that crawls from one end of the country to the other, straddling two sets of three-meter-wide tracks. Each carriage is twenty by forty meters, and there are seventy-five of them.[30] The environment surrounding the tracks, like a demilitarized zone, is fully naturalized, a sort of nature paradise to be enjoyed by nature-loving communo-nuclearists from the safety of their train.

Dunne & Raby, *Train*, from *United Micro Kingdoms*, 2013. CGI by Tommaso Lanza.

The state provides everything. They depend on nuclear energy for their continued survival and, although they are energy rich it comes at a price—no one wants to live near them and they are under constant threat of attack or accident, even though their energy source uses a relatively safe thorium reactor. Consequently, they are organized as a highly disciplined mobile micro-state. Fully centralized, everything is planned and regulated. They are voluntary prisoners of pleasure, free from the pressures of daily survival, communists sharing in luxury not poverty. Like a popular night club there is a one-out one-in policy but for life.

Dunne & Raby, *Train*, from *United Micro Kingdoms*, 2013.

Inhabitants live inside the mountains, which contain labs, factories, hydroponic gardens, gyms, dorms, kitchens, nightclubs, and everything else they need. On the mountains are swimming pools, fish farms, and bookable huts for periods of isolation.

Although inspired by 1950s, 1960s, and 1970s dreams of space colonies, older UMK dwellers see echoes of early twenty-first-century Dubai on tracks. The train allows two very different sides of their collective psychology to flourish. At times it is a hedonistic playground, a very loud, vast mobile pleasure paradise announced in advance by a slow thumping sound, like a party cruise boat on the Thames. But mostly, like the 1930s Californian homesteaders it is a community seeking isolation on the edges of civilization, away from the detrimental effects of the Anthropocene. An ecological wilderness similar to demilitarized zones has emerged along its route where an absence of humans means an abundance of wildlife, and rare species can thrive. Anyone who gets too close is zapped with a noise cannon. Their survival requires extraordinary discipline, but to maintain mental well-being in such a confined environment, diversity is accommodated as much as is possible.

The train is an aid for imagining alternative ways of organizing everyday life within a zero growth system. It is designed to be suggestive, for people to wonder what might lie inside the mountains, how it would work, and what it would be like to live on. The potential for this kind of design—inspired by policy, social science, and the world around us but expressed through imaginative design speculations is beautifully put by the Wellcome Trust's Ken Arnold speaking about what design has to offer other disciplines such as science:

Dunne & Raby, *Train*, from *United Micro Kingdoms*, 2013. Photograph by Jason Evans.

[Design can be] the stable platform on which to entertain unusual bedfellows. The glue for things that may not be naturally sticky. The lubricant that allows movement between ideas that don't quite run together. The medium through which we can make otherwise awkward connections and comparisons. The language for tricky conversations and translations.[31]

Dunne & Raby, *Train*, from *United Micro Kingdoms*, 2013. Photograph by Jason Evans.

NEW REALITIES

As we rapidly move toward a monoculture that makes imagining genuine alternatives almost impossible, we need to experiment with ways of developing new and distinctive worldviews that include different beliefs, values, ideals, hopes, and fears from today's. If our belief systems and ideas don't change, then reality won't change either. It is our hope that speculating through design will allow us to develop alternative social imaginaries that open new perspectives on the challenges facing us.

The idea of the "proposal" is at the heart of this approach to design: to propose, to suggest, to offer something. This is what design is good at. It can sketch out possibilities. Although these proposals draw from rigorous analysis and thorough research, it's important they do not lose their imaginative, improbable, and provocative qualities. They are closer to literature than social science, emphasize imagination over practicality, and ask questions rather than provide answers. The project's value is not what it achieves or does but what it is and how it makes people feel, especially if it encourages people to question, in an imaginative, troubling, and thoughtful way, everydayness and how things could be different. To be effective, the work needs to contain contradictions and cognitive glitches. Rather than offering an easy way forward, it highlights dilemmas and trade-offs between imperfect alternatives. Not a solution, not a "better" way, just another way. Viewers can make up their own minds.

This is where we believe speculative design can flourish—providing complicated pleasure, enriching our mental lives, and broadening our minds in ways that complement other media and disciplines. It's about meaning and culture, about adding to what life could be, challenging what it is, and providing alternatives that loosen the ties reality has on our ability to dream. Ultimately, it is a catalyst for social dreaming.

NOTES

CHAPTER 1

1. Stephen Duncombe, *Dream: Re-imaging Progressive Politics in an Age of Fantasy* (New York: The New Press, 2007), 182.

2. For example, see Barbara Adam, "Towards a New Sociology of the Future" (Draft). Available at http://www.cf.ac.uk/socsi/futures/newsociologyofthefuture.pdf. Accessed December 24, 2012.

3. For more on this, see Joseph Voros, "A Primer on Futures Studies, Foresight and the Use of Scenarios," *Prospect, the Foresight Bulletin*, no. 6 (December 2001). Available at http://thinkingfutures.net/wp-content/uploads/2010/10/A_Primer_on_Futures_Studies1.pdf. Accessed December 21, 2012.

4. Michio Kaku, *Physics of the Impossible* (London: Penguin Books, 2008).

5. David Kirby, *Lab Coats in Hollywood: Science, Scientists, and Cinema* (Cambridge, MA: MIT Press, 2011), 145-168.

6. Richard Barbrook, *Imaginary Futures: From Thinking Machines to the Global Village* (London: Pluto Press, 2007).

7. This history is very well documented; for example, see Neil Spiller, *Visionary Architecture: Blueprints of the Modern Imagination* (London: Thames & Hudson, 2006); Felicity D. Scott, *Architecture or Techno-utopia: Politics after Modernism* (Cambridge, MA: MIT Press, 2007); Robert Klanten et al., eds., *Beyond Architecture: Imaginative Buildings and Fictional Cities* (Berlin: Die Gestalten Verlag, 2009); and Geoff Manaugh, *The BLDG BLOG Book* (San Francisco: Chronicle Books, 2009); see also http://bldgblog.blogspot.co.uk. Accessed December 24, 2012.

8. Zygmunt Bauman, *Liquid Modernity* (Cambridge, UK: Polity Press 2000).

CHAPTER 2

1. For an in depth discussion of the how of speculative design, see James

Auger, "Why Robot? Speculative Design, Domestication of Technology and the Considered Future," PhD diss. (London: Royal College of Art, 2012), 153–164.

2. For more on critical design, see our earlier books, Anthony Dunne, *Hertzian Tales* (Cambridge, MA: MIT Press, 2005); and Anthony Dunne and Fiona Raby, *Design Noir* (Basel: Birkhäuser, 2001).

3. See Julian Bleecker, *Design Fiction: A Short Essay on Design, Science, Fact and Fiction* (2009). Available at http://nearfuturelaboratory. com/2009/03/17/design-fiction-a-short-essay-on-design-science-fact-and-fiction/. Accessed December 23, 2012. For examples, see Bruce Sterling's *Beyond the Beyond* blog at http://www.wired.com/beyond_the_beyond. Accessed December 24, 2012.

4. Stuart Candy's *The Sceptical Futuryst* blog is a wonderful repository of ideas and projects on design and futures. Available at http://futuryst. blogspot.co.uk. Accessed December 20, 2012.

5. Krzysztof Wodiczko's Interrogative Design Group has as its goal "to combine art and technology into design while infusing it with emerging cultural issues that play critical roles in our society yet are given the least design attention." Available at http://www.interrogative.org/about. Accessed December 24, 2012.

6. Carl DiSalvo, *Adversarial Design* (Cambridge, MA: MIT Press, 2010), explores ways this kind of design can engage with the political.

7. For more on this, see Bruce M. Tharp and Stephanie M. Tharp, The 4 Fields of Industrial Design: (No, Not Furniture, Trans, Consumer Electronics & Toys), *Core77* blog, January 5, 2009. Available at http://www.core77.com/ blog/featured_items/the_4_fields_of_industrial_design_no_not_furniture_ trans_consumer_electronics_toys_by_bruce_m_tharp_and_stephanie_m_ tharp__12232.asp. Accessed December 23, 2012.

8. See Anab Jain et al., "Design Futurescaping," in *Blowup: The Era of Objects*, ed. Michelle Kaprzak (Amsterdam: V2, 2011), 6–14. Available at http://www.v2.nl/files/2011/events/blowup-readers/the-era-of-objects-pdf. Accessed December 23, 2012.

9. Tim Black, interview with Susan Neiman, *Spiked Online.* Available at http://

www.spiked-online.com/index.php/site/reviewofbooks_article/7214. Acccssed December 24, 2012.

10. Hans Vaihinger, *The Philosophy of "As If"* (Eastford, CT: Martino Publishing, 2009 [1925]), 48.

11. In Vailinger, *The Philosophy of "As If,"* 268, Vailinger makes a helpful distinction between hypothesis and fiction: "Whereas every hypothesis seeks to be an adequate expression of some reality still unknown and to mirror this objective reality correctly, the fiction is advanced with the consciousness that it is an inadequate, subjective and pictorial manner of conception, whose coincidence with reality is, from the start, excluded and which cannot, therefore, be afterwards verified, as we hope to be able verify an hypothesis."

12. Sol LeWitt, "Sentences on Conceptual Art," *Art-Language: The Journal of Conceptual Art*, 1 (1) (May 1969): 11–13, in Peter Osborne, *Conceptual Art* (London: Phaidon, 2005 [2002]), 222.

13. Ibid.

14. This was first suggested to us in a conversation with Deyan Sudjic in 2011.

15. Will Bradley and Charles Esche, eds., *Art and Social Change: A Critical Reader* (London: Tate Publishing, 2007), 13.

16. For example, see Robert Klanten et al., eds., *Furnish: Furniture and Interior Design for the 21st Century* (Berlin: Die Gestalten Verlag, 2007); and Gareth Williams, *Telling Tales: Fantasy and Fear in Contemporary Design* (London: V&A Publishing, 2009).

17. See Suzanne Frank, *Peter Eisenman's House VI: The Client's Response* (New York: Watson-Guptil Publications, 1994).

18. For a detailed discussion of device art see Machiko Kusahara, "Device Art: A New Approach in Understanding Japanese Contemporary Media Art," in *Media Art Histories*, ed. Oliver Grau (Cambridge, MA: MIT Press, 2007), 277–307.

19. For more examples and discussion of work like this, see Conny Freyer et al., eds., *Digital by Design* (London: Thames and Hudson, 2008).

CHAPTER 3

1. Tim Black, interview with Susan Neiman, *Spiked Online*. Available at http://www.spiked-online.com/index.php/site/reviewofbooks_article/7214. Accessed December 24, 2012.

2. Andrew Feenberg, *Transforming Technology, A Critical Theory Revisited* (Oxford: Oxford University Press, 2002 [1991]), 19.

3. See for example Ramia Mazé and Johan Redström, "Difficult Forms: Critical Practices of Design and Research," *Research Design Journal* 1, no. 1 (2009): 28-39.

4. See for example, the introduction to the Museum of Modern Art's *Talk to Me* exhibition in 2011. Available at http://www.moma.org/interactives/exhibitions/2011/talktome/home.html. Accessed December 24, 2012.

5. See for example Edwin Heathcote, "Critical Points," *Financial Times* (April 1, 2010). Available at http://www.ft.com/cms/s/2/24150a88-3c4e-11df-b316-00144feabdc0.html#axzz2Fu1AF35b. Accessed December 24, 2012.

6. Most interestingly for us, it has become entangled with several related terms—*adversarial design, discursive design, conceptual design, speculative design,* and *design fiction*—that together are setting out a broader role for design firmly located in a cultural, social, and political context rather than a purely business one.

7. A good example of this is the tax protests and boycotts organized by UK Uncut against corporate tax avoidance by multinational corporations on profits made in the United Kingdom.

8. Erik Olin Wright, *Envisioning Real Utopias* (London: Verso, 2010), 67-68.

9. Ibid., 68.

10. For a detailed discussion of observational comedy and speculative design, see James Auger, "Why Robot? Speculative Design, Domestication of Technology and the Considered Future," PhD diss. (London: Royal College of Art, 2012), 164-168.

11. Wright, *Envisioning Real Utopias*, 25-26.

CHAPTER 4

1. Andrew Feenberg, *Transforming Technology, A Critical Theory Revisited* (Oxford: Oxford University Press, 2002 [1991]), vi.

2. For an in depth exploration of this weird and wonderful world, see Koert Van Mensvoort, *Next Nature: Nature Changes Along with Us* (Barcelona: Actar, 2011).

3. In 2002 Nexia Biotechnologies produced a genetically modified goat whose milk contained super strong spider silk protein.

4. With synthetic biology we may have reached a point at which entirely new life forms can be engineered to order. In 2010 Craig Venter and his team created "Synthia," arguably the first artificial life form or, more accurately, the most synthetic organism ever made. Using an existing cell and DNA synthesizer (a "printing" machine with four bottles containing ATCG, the four chemicals that make up our DNA chain), they created a genome that they put into another cell that had its DNA removed; it then reproduced the synthetic DNA. At the press conference Venter claimed its "parent was a computer" rather than an organic organism.

5. For more on this, see Stephen Wilson, *Art + Science: How Scientific Research and Technological Innovation Are Becoming Key to 21st-century Aesthetics* (London: Thames & Hudson, 2010); and Ingeborg Reichle, *Art in the Age of Technoscience: Genetic Engineering, Robotics, Artificial Life in Contemporary Life* (Vienna: Springer-Verlag, 2009).

6. For example, see James Wilsdon and Rebecca Willis, *See-through Science* (London: Demos Pamphlet, 2004). Available at http://www.demos.co.uk/publications/paddlingupstream.

7. The designer was aware this was very unlikely to be an authentic hair.

CHAPTER 5

1. Lubomír Doležel, *Heterocosmica: Fiction and Possible Worlds* (Baltimore: John Hopkins University Press, 1998), ix.

2. Keith Oatley, *Such Stuff as Dreams: The Psychology of Fiction* (Oxford: Wiley-Blackwell, 2011), 30.

3. Doležel, *Heterocosmica*, 13.

4. See Mauricio Suárez, ed., *Fictions in Science: Philosophical Essays on Modeling and Idealization* (London: Routledge, 2009).

5. For more on this see Richard Mark Sainsbury, *Fiction and Fictionalism* (London: Routledge, 2009). Kindle edition.

6. See Nancy Spector, *Matthew Barney: The Cremaster Cycle* (New York: Guggenheim Museum, 2002).

7. For more on this, see Mary Flanagan, *Critical Play: Radical Game Design* (Cambridge, MA: MIT Press, 2009).

8. Lyman Tower Sargent, *Utopianism: A Very Short Introduction* (Oxford: Oxford University Press, 2010), 5.

9. Eric Olin Wright, *Envisioning Real Utopias* (London: Verso, 2010), 5.

10. In Sargent, *Utopianism*, 114.

11. For example, see Raffaella Baccolini and Tom Moylan, eds., *Dark Horizons: Science Fiction and the Dystopian Imagination* (New York: Routledge, 2003); and Carl Freedman, *Critical Theory and Science Fiction* (Middletown, CT: Wesleyan University Press, 2000).

12. Francis Spufford, *Red Plenty* (London: Faber and Faber, 2010), 3. Kindle edition.

13. Available at http://www.justinmcguirk.com/home/the-post-spectacular-economy.html.

14. Interview available at http://bldgblog.blogspot.co.uk/2011/03/unsolving-city-interview-with-china.html. Accessed December 20, 2012.

15. For an extensive list of classic thought experiments from disciplines including philosophy, biology, and economics, see http://en.wikipedia.org/wiki/Thought_experiment. Accessed December 20, 2012.

16. For an in-depth discussion of different kinds of thought experiments, see Julian Baggini, *The Pig That Wants to Be Eaten: And Ninety-Nine Other Thought Experiments* (London: Granta, 2005).

17. Stephen R. L. Clark, *Philosophical Futures* (Frankfurt am Main: Peter Lang, 2011), 17.

18. "The World in 2036: Design Takes Over, Says Paola Antonelli," *Economist Online*, November 22, 2010. Available at http://www.economist.com/node/17509367. Accessed December 24, 2012.

19. Milan Kundera, *The Art of the Novel* (New York: Grove Press, 1988).

CHAPTER 6

1. "Icon Minds: Tony Dunne/Fiona Raby/Bruce Sterling on Design Fiction." A public conversation organized by *Icon Magazine*, London, October 14, 2009. Notes from the conversation are available at http://magicalnihilism.com/2009/10/14/icon-minds-tony-dunne-fiona-raby-bruce-sterling-on-design-fiction. Accessed December 24, 2012.

2. Piers D. Britton, "Design for Screen SF," in *The Routledge Companion to Science Fiction*, eds. Mark Bould et al. (London: Routledge, 2009), 341–349.

3. In Stuart Candy, "In Praise of *Children of Men*" (*The Sceptical Futuryst* blog, April 12, 2008). Available at http://futuryst.blogspot.com/2008/04/in-praise-of-children-of-men.html. Accessed December 23, 2012.

4. Linda Michael and Patricia Piccinini, *We Are Family* (Surry Hills: Australia Council, 2003).

5. Kendall L. Walton, *Mimesis as Make-Believe: On the Foundations of the Representational Arts* (Cambridge, MA: Harvard University Press, 1990).

6. "Briefly, a fictional truth consists in of there being a prescription or mandate in some context to imagine something. Fictional propositions are propositions that are *to be* imagined—whether or not they are in fact imagined." In Walton, *Mimesis as Make-Believe*, 39.

7. Keith Oatley, *Such Stuff as Dreams: The Psychology of Fiction* (Oxford: Wiley-Blackwell, 2011), 130.

8. Charles Avery, *The Islanders: An Introduction* (London: Parasol Unit/Koenig Books, 2010).

9. See for example, "Hawaii 2050," by Stuart Candy, Jon Dator, and Jake Dunagan. Available at http://www.futures.hawaii.edu/publications/hawaii/FourFuturesHawaii2050-2006.pdf. Accessed December 24, 2012. A write-up of the experimental part of the project by Stuart Candy is available at http://futuryst.blogspot.co.uk/2006/08/hawaii-2050-kicks-off.html. Accessed December 24, 2012.

10. For more discussion on this, see http://tvtropes.org/pmwiki/pmwiki.php/Main/WillingSuspensionOfDisbelief. Accessed December 24, 2012.

11. James Wood, *How Fiction Works* (London: Jonathan Cape, 2008), 179.

12. Wood, *How Fiction Works*, 28-29.

13. David Kirby writes of diegetic prototypes: "[They] . . . demonstrate to large public audiences a technology's utility, harmlessness, and viability. Diegetic prototypes have a major rhetorical advantage even over true prototypes: in the fictional world—what film scholars refer to as the diegesis—these technologies exist as 'real' objects that function properly and that people actually use." David A. Kirby, *Lab Coats in Hollywood: Science, Scientists, and Cinema* (Cambridge, MA: MIT Press, 2011), 195.

14. Torie Bosch, "Sci-Fi Writer Bruce Sterling Explains the Intriguing New Concept of Design Fiction," *Slate* blog, March 2, 2012. Available at http://www.slate.com/blogs/future_tense/2012/03/02/bruce_sterling_on_design_fictions_.html. Accessed December 24, 2012.

15. See Brian David Johnson, *Science Fiction for Prototyping: Designing the Future with Science Fiction* (San Francisco: Morgan & Claypool Publishers, 2011).

CHAPTER 7

1. Keith Oatley, *Such Stuff as Dreams: The Psychology of Fiction* (Oxford: Wiley-Blackwell, 2011), 37.

2. For more on this, see Langdon Winner, *The Whale and the Reactor: A Search for Limits in an Age of High Technology* (Chicago: University of Chicago Press, 1986).

3. See Branko Lukić, *Nonobject* (Cambridge, MA: MIT Press, 2011).

4. Terence Riley, ed., *The Changing of the Avant-Garde: Visionary Architectural Drawings from the Howard Gilman Collection* (New York: The Museum of Modern Art, 2002). Available at http://www.moma.org/collection/object.php?object_id=922. Accessed April 4, 2013.

5. "A term attributed to Hitchcock, the MacGuffin is a cinematic plot device, usually an object, that serves to set and keep the story in motion despite lacking intrinsic importance. Famous examples include the statue from *The Maltese Falcon*, the glowing suitcase from *Kiss Me Deadly*, the bottle of uranium in *Notorious*, and the letters of transit in *Casablanca*." Available at http://noamtoran.com/NT2009/projects/the-macguffin-library. Accessed December 20, 2012.

6. ATOPOS cvc and Vassilis Zidianakis, *Not a Toy: Fashioning Radical Characters* (Berlin: Pictoplasma Publishing, 2011).

7. Lars Tunbjörk, *Office* (Stockholm: Journal, 2001).

8. See Ann Thomas, *The Photography of Lynne Cohen* (London: Thames & Hudson, 2001).

9. See Taryn Simon, *An American Index of the Modern and Unfamiliar* (Göttingen: Steidl, 2007).

10. See Richard Ross, *Architecture of Authority* (New York:Aperture Foundation, 2007).

11. See Lucinda Devlin, *The Omega Suites* (Göttingen: Steidl, 2000).

12. See Mike Mandel and Larry Sultan, *Evidence* (New York: D.A.P./Distributed Art Publishers, 1977).

CHAPTER 8

1. The video is available at http://www.youtube.com/watch?v=gnb-rdGbm6s&feature=relmfu. Accessed December 20, 2012.

2. The results were exhibited at the RCA, March 15-21, 2010. The project was commissioned by EPSRC and partly supported by Nesta.

3. The ideas stage of this project was commissioned by Design Indaba as part of *Protofarm 2050* for the 2009 ICSID World Design Congress in Singapore.

4. Giles Oldroyd, a plant scientist at the John Innes Research Centre, is using transgenic plants to replace oil-based fertilizer. Pea plants have nitrogen-producing abilities: they have nodes in their roots that are nitrogen factories. If pea plants are spliced with wheat there is no need for nitrogen fertilizer. Nitrogen fertilizer increases yields by 50 percent; however, nitrogen fertilizer is oil-based and if absorbed can poison other plants and animals, particularly fish when it gets into water. He argues using transgenic plants is a more "natural" process based on biological principles. The more scientists understand how biology works, the more they can design within biological principles. For more information, see http://www.foodsecurity.ac.uk/blog/index.php/2010/03/getting-to-the-root-of-food-security.

5. At the MoMA/SEED Design and the Elastic Mind Symposium on April 4, 2008, Drew Endy from the bioengineering department at Stanford told the audience, "there are 250,000 plant species in the world and only a tiny number are edible. Synthetic biology can be used to modify plants to make them more digestible and nutritious." See also http://openwetware.org/wiki/Endy_Lab.

6. John Gray, *Endgames: Questions in Late Modern Political Thought* (Cambridge, UK: Polity Press, 1997), 186.

7. Interview with Jan Boelen. Available at http://www.arterritory.com/en/texts/interviews/538-between_art_and_design,_without_borders/2. Accessed December 24, 2012.

CHAPTER 9

1. From Nico Macdonald's seminar "Designerly Thinking and Beyond" for design interactions MA students at the RCA (January 25, 2006). Available at http://www.spy.co.uk/Communication/Talks/Colleges/RCA_ID/2006. Accessed December 24, 2012.

2. See Richard Thaler and Cass Sunstein, *Nudge: Improving Decisions about Health, Wealth, and Happiness* (London: Penguin, 2009).

3. For more on this, see B. J. Fogg, *Persuasive Technology: Using Computers to Change What We Think and Do* (Burlington, MA: Morgan Kaufmann, 2003).

4. Available at http://www.cabinetoffice.gov.uk/behavioural-insights-team. Accessed December 23, 2012.

5. Eric Olin Wright, *Envisioning Real Utopias* (London: Verso, 2010), 23.

6. Ibid.

7. Keith Oatley, *Such Stuff as Dreams: The Psychology of Fiction* (Oxford: Wiley-Blackwell, 2011), 118.

8. Philip K. Dick, *How to Build a Universe That Doesn't Fall Apart Two Days Later* (speech given in 1978). Available at http://deoxy.org/pkd_how2build.htm. Accessed December 24, 2012.

9. Timothy Archibald, *Sex Machines* (Los Angeles: Process, 2005).

10. For example, see Nicolas Bourriaud, *Relational Aesthetics* (Paris: Les Presse Du Reel, 1998); and Christian Gether et al., eds., *Utopia & Contemporary Art* (Ishøj: ARKEN Museum of Modern Art, 2012).

11. For example, the Delphi technique in the 1950s. A group of experts are asked for their views on a specific subject then told what others thought so

creating a feedback loop that eventually either produces a consensus or narrows down the possibilities.

12. The word *ideology* was coined by French thinker Antoine Destutt de Tracy in the 1790s. He was interested in developing a science of ideas. That didn't happen but the word did develop other meanings. We are aware the word *ideology* has negative associations. For many, ideology masks true reality to protect the interests of a ruling class but its original purpose was simply to examine political ideas and theory. For us, ideology is a way of thinking about worldviews and the narrative glue that joins values, beliefs, priorities, hopes, and fears together. Despite its negative associations, we think it is a useful term.

13. Available at http://www.instapaper.com/go/205770677/text. Accessed December 23, 2012.

14. For more, see http://www.slate.com/articles/health_and_science/new_scientist/2012/09/floating_cities_seasteaders_want_to_build_their_own_islands_.html. Accessed December 24, 2012.

15. Available at http://www.massivechange.com. Accessed December 24, 2012.

16. Available at http://www.designgeopolitics.org/about. Accessed December 24, 2012.

17. William Morris, *News from Nowhere* (Oxford: Oxford University Press, 2009).

18. See Metahaven and Marina Vishmidt, eds., *Uncorporate Identity* (Baden: Lars Müller Publishers, 2010).

19. Andrea Hyde, *Metahaven's Facestate Social Media and the State: An Interview with Metahaven*. Available at http://www.walkerart.org/magazine/2011/metahavens-facestate. Accessed December 23, 2012.

20. The project was commissioned by the Design Museum in London and exhibited there as "The United Micro Kingdoms: A Design Fiction" between May 1 and August 25, 2012.

21. James Dobbins et al., *The Beginner's Guide to Nation-Building* (Santa Monica: RAND Corporation, 2007). Available at http://www.rand.org/pubs/monographs/MG557.html. Accessed December 24, 2012.

22. Torie Bosch, "Sci-Fi Writer Bruce Sterling Explains the Intriguing New Concept of Design Fiction," *Slate* blog, March 2, 2012. Available at http://www.slate.com/blogs/future_tense/2012/03/02/bruce_sterling_on_design_fictions_.html. Accessed December 24, 2012.

23. This title is from a document Cynthia Weber, a professor of international relations, produced for a student project we ran related to this theme. It set out areas we would need to think about if we were to design a state: who are we? (population); where are we? (territory); who governs us? (authority); do other states think we are a state? (recognition).

24. See for example, *The Nolan Chart* and *The Political Compass*, available at http://www.politicalcompass.org. Accessed June 30, 2013.

25. For other fictional Englands, see Rupert Thomson, *Divided Kingdom* (London: Bloomsbury, 2006); and Julian Barnes, *England England* (London: Picador, 2005 [1988]).

26. Timothy Mitchell, "Hydrocarbon Utopia," in *Utopia/Dystopia: Conditions of Historical Possibility*, ed. Michael D. Gordin, Helen Tilley, and Gyan Prakish (Princeton, NJ: Princeton University Press, 2010), 118.

27. For more about how the design of cars can change to due to *robocars,* see Brad Templeton, "New Design Factors for Robot Cars." Available at http://www.templetons.com/brad/robocars/design-change.html. Accessed December 23, 2012.

28. Each micro-kingdom represents a different combination of technology and political ideology. For example, if biotechnology were part of the digitarian world, it would be shaped by market mechanisms and lead to a "bio-tarian" culture. Likewise, if the bioliberals embraced digital technology, it would result in a "digi-liberal" culture. But which comes first, technology or ideology?

29. A technology currently being developed at the Auckland Bioengineering Institute in New Zealand for motors used in robots. See more about this technology at http://www.popsci.com/technology/article/2011-03/video-jelly-artificial-muscles-create-rotary-motion-could-make-robots-more-flexible. Accessed December 24, 2012.

30. For other fictional train worlds, see Christopher Priest, *Inverted World* (London: SF Gateway, 2010 [1974]). Kindle edition; China Miéville, *Railsea* (London: Macmillan, 2012). Kindle edition.

31. Ken Arnold, "Designing Connections: Medicine, Life and Art," Bicentenary Medal Lecture (London: Royal Society of the Arts, November 2, 2011).

BIBLIOGRAPHY

Abbott, Edwin A. *Flatland: A Romance of Many Dimensions*. Oxford: Oxford
 University Press, 2008 [1867].

Albero, Alexander, and Sabeth Buchmann, eds. *Art after Conceptual Art*.
 Cambridge, MA: MIT Press, 2006.

Ambasz, Emilio, ed. *The New Domestic Landscape: Achievements and Problems of
 Italian Design*. New York: Museum of Modern Art, 1972.

Antonelli, Paola. *Design and the Elastic Mind*. New York: Museum of Modern Art,
 2008.

Archibald, Timothy. *Sex Machines*. Los Angeles: Process, 2005.

Ashley, Mike. *Out of This World: Science Fiction but Not as You Know It*.
 London: The British Library, 2011.

ATOPOS CVC and Vassilis Zidianakis. *Not a Toy: Fashioning Radical Characters*.
 Berlin: Pictoplasma Publishing, 2011.

Atwood, Margaret. *Oryx and Crake*. London: Bloomsbury, 2003.

Auger, James. Why Robot? Speculative Design, Domestication of Technology
 and the Considered Future, PhD diss. (London: Royal College of Art,
 2012).

Avery, Charles. *The Islanders: An Introduction*. London: Parasol Unit/Koenig
 Books, 2010.

Azuma, Hiroki. *Otaku: Japan's Database Animals*. Minneapolis: University of
 Minnesota Press, 2009 [2001].

Baccolini, Raffaella, and Tom Moylan, eds. *Dark Horizons: Science Fiction and
 the Dystopian Imagination*. New York: Routledge, 2003.

Baggini, Julian. *The Pig That Wants to Be Eaten: And Ninety-Nine Other Thought Experiments*. London: Granta, 2005.

Ballard, J. G. *Super-Cannes*. London: Flamingo, 2000.

Ballard, J. G. *Millennium People*. London: Flamingo, 2004.

Barbrook, Richard. *Imaginary Futures: From Thinking Machines to the Global Village*. London: Pluto Press, 2007.

Bateman, Chris. *Imaginary Games*. London: Zero Books, 2011.

Bauman, Zygmunt. *Liquid Modernity*. Cambridge, UK: Polity Press, 2000.

Beaver, Jacob, Tobie Kerridge, and Sarah Pennington, eds. *Material Beliefs*. London: Goldsmiths, University of London, 2009.

Bel Geddes, Norman. *Magic Motorways*. Milton Keynes, UK: Lightning Sources, 2010. [c1940]

Bell, Wendell. *Foundations of Futures Studies*. London: Transaction Publishers, 2007 [1997].

Bingham, Neil, Clare Carolin, Rob Wilson, and Peter Cook, eds. *Fantasy Architecture, 1500–2036*. London: Hayward Gallery, 2004.

Bleecker, Julian. *Design Fiction: A Short Essay on Design, Science, Fact and Fiction*. 2009. Available at http://nearfuturelaboratory. com/2009/03/17/design-fiction-a-short-essay-on-design-science-fact-and-fiction. Accessed December 23, 2012.

Boese, Alex. *Elephants on Acid: And Other Bizarre Experiments*. London: Boxtree, 2008.

Bould, Mark, Andrew M. Butler, Adam Roberts, and Sherryl Vint, eds. *The Routledge Companion to Science Fiction*. London: Routledge, 2009.

Bourriaud, Nicolas. *Altermodern*. London: Tate Publishing, 2009.

Bradley, Will, and Charles Esche, eds. *Art and Social Change: A Critical Reader*. London: Tate Publishing, 2007.

Breitwiesser, Sabine, ed. *Designs for the Real World*. Vienna: Generali Foundation, 2002.

Brockman, John, ed. *What Is Your Dangerous Idea?* London: Simon & Schuster, 2006.

Burrett, Alex. *My Goat Ate Its Own Legs*. London: Burning House Books, 2008.

Cardinal, Roger, Jon Thompson, Whitechapel Art Gallery (London), Fundación "La Caixa" (Madrid), and Irish Museum of Modern Art (Dublin). *Inner Worlds Outside*. London: Whitechapel Gallery, 2006.

Carey, John, ed. *The Faber Book of Utopias*. London: Faber and Faber, 1999.

Christopher, John. *The Death of Grass*. London: Penguin Books, 2009 [1956].

Clark, Stephen R. L. *Philosophical Futures*. Frankfurt am Main: Peter Lang, 2011.

Coleman, Nathaniel. *Utopias and Architecture*. London: Routledge, 2005.

Cooper, Richard N., and Richard Layard, eds. *What the Future Holds: Insights from Social Science*. Cambridge, MA: MIT Press, 2003.

da Costa, Beatrice, and Philip Kavita, eds. *Tactical Biopolitics: Art, Activism, and Technoscience*. Cambridge, MA: MIT Press, 2008.

Crowley, David, and Jane Pavitt, eds. *Cold War Modern: Design 1945-1970*. London: V&A Publishing, 2008.

Devlin, Lucinda. *The Omega Suites*. Göttingen: Steidl, 2000.

Dickson, Paul. *Think Tanks*. New York: Atheneum, 1971.

DiSalvo, Carl. *Adversarial Design*. Cambridge, MA: MIT Press, 2010.

Dixon, Dougal. *After Man: A Zoology of the Future*. New York: St. Martin's Press, 1981.

Doležel, Lubomír. *Heterocosmica: Fiction and Possible Worlds*. Baltimore: Johns Hopkins University Press, 1998.

Duncombe, Stephen. *Dream: Re-imagining Progressive Politics in an Age of Fantasy*. New York: The New Press, 2007.

Elton, Ben. *Blind Faith*. 2008. London: Transworld Publishers.

Ericson, Magnus, and Mazé Ramia, eds. *Design Act: Socially and Politically Engaged Design Today—Critical Roles and Emerging Tactics*. Berlin: Iaspis/Sternberg, 2011.

Feenberg, Andrew. *Transforming Technology: A Critical Theory Revisited*. Oxford: Oxford University Press, 2002 [1991].

Feenberg, Andrew. *Questioning Technology*. New York: Routledge, 1999.

Fisher, Mark. *Capitalist Realism: Is There No Alternative*. Winchester: 0 Books, 2009.

Flanagan, Mary. *Critical Play: Radical Game Design*. Cambridge, MA: MIT Press, 2009.

Fogg, B. J. *Persuasive Technology: Using Computers to Change What We Think and Do*. San Francisco: Morgan Kaufmann, 2003.

Fortin, David T. *Architecture and Science-Fiction Film: Philip K. Dick and the Spectacle of the Home*. Farnham, UK: Ashgate, 2011.

Freeden, Michael. *Ideology: A Very Short Introduction*. Oxford: Oxford University Press, 2003.

Freedman, Carl. *Critical Theory and Science Fiction*. Middletown, CT: Wesleyan University Press, 2000.

Freyer, Conny, Sebastien Noel, and Eva Rucki, eds. *Digital by Design*. London: Thames and Hudson, 2008.

Friesen, John W., and Virginia Lyons Friesen. *The Palgrave Companion to North American Utopias*. New York: Palgrave MacMillan, 2004.

Fry, Tony. *Design as Politics*. Oxford: Berg, 2011.

Fuller, Steve. *The Intellectual*. Cambridge, UK: Icon Books, 2005.

Geuss, Raymond. *The Idea of a Critical Theory: Habermas & the Frankfurt School*. Cambridge, UK: Cambridge University Press, 1981.

Ghamari-Tabrizi, Sharon. *The Worlds of Herman Kahn*. Cambridge, MA: MIT Press, 2005.

Goodman, Nelson. *Ways of Worldmaking*. Indianapolis: Hackett Publishing Company, 1978.

Gray, John. *Endgames: Questions in Late Modern Political Thought*. Cambridge, UK: Polity Press, 1997.

Gray, John. *False Dawn: The Delusions of Global Capitalism*. London: Granta, 2002 [1998].

Gray, John. *Straw Dogs: Thoughts on Human and Other Animals*. London: Granta, 2003.

Gray, John. *Heresies: Against Progress and Other Illusions*. London: Granta, 2004.

Gun, James, and Matthew Candelaria, eds. *Speculations on Speculation*. Lanham, MD: Scarecrow Press, 2005.

Halligan, Fionnuala. *Production Design*. Lewes, UK: ILEX, 2012.

Hanson, Matt. *The Science behind the Fiction: Building Sci-Fi Moviescapes*. Sussex, UK: Rotovision, 2005.

Hauser, Jens, ed. *Sk-interfaces: Exploding Borders—Creating Membranes in Art, Technology and Society*. Liverpool: Fact/Liverpool University Press, 2008.

Hughes, Rian, and Imogene Foss. *Hardware: The Definitive Works of Chris Foss*. London: Titan Books, 2011.

Ihde, Don. *Postphenomenology and Technoscience*. Albany: State University of New York, 2009.

Iser, Wolfgang. *The Fictive and the Imaginary: Charting Literary Anthropology*. Baltimore: John Hopkins University, 1993.

Jacoby, Russell. *Picture Imperfect: Utopian Thought for an Anti-Utopian Age*. New York: Columbia University Press, 2005.

Jameson, Frederic. *Archaeologies of the Future: The Desire Called Utopia and Other Science Fictions*. London: Verso, 2005.

Joern, Julia, and Cameron Shaw, eds. *Marcel Dzama: Even the Ghost of the Past*. New York: Steidl and David Zwirner, 2008.

Johnson, Brian David. *Science Fiction for Prototyping: Designing the Future with Science Fiction*. San Francisco: Morgan & Claypool Publishers, 2011.

Jones, Caroline A., ed. *Sensorium: Embodied Experience Technology, and Contemporary Art*. Cambridge, MA: MIT Press, 2006.

Kaku, Michio. *Physics of the Impossible*. London: Penguin Books, 2008.

Kalliala, Martti, Jenna Sutela, and Tuomas Toivonen. *Solution 239-246: Finland: The Welfare Game*. Berlin: Sternberg Press, 2011.

Keasler, Misty. *Love Hotels: The Hidden Fantasy Rooms of Japan*. San Francisco: Chronicle Books, 2006.

Keiller, Patrick. *The Possibility of Life's Survival on the Planet*. London: Tate Publishing, 2012.

Kelly, Marjorie. *The Divine Right of Capital: Dethroning the Corporate Aristocracy*. San Francisco: Berrett-Koehler, 2001.

Kipnis, Jeffrey. *Perfect Acts of Architecture*. New York: Museum of Modern Art, 2001.

Kirby, David A. *Lab Coats in Hollywood: Science, Scientists, and Cinema*. Cambridge, MA: MIT Press, 2011.

Kirkham, Pat. *Charles and Ray Eames: Designers of the Twentieth Century*. Cambridge, MA: MIT Press, 1995.

Klanten, Robert and Lukas Feireiss, eds. *Beyond Architecture: Imaginative Buildings and Fictional Cities*. Berlin: Die Gestalten Verlag, 2009.

Klanten, Robert, Sophie Lovell, and Birga Meyer, eds. *Furnish: Furniture and Interior Design for the 21st Century*. Berlin: Die Gestalten Verlag, 2007.

Kullmann, Isabella, and Liz Jobey, eds. *Hannah Starkey Photographs 1997-2007*. Göttingen: Steidl, 2007.

Lang, Peter, and William Menking. *Superstudio: Life without Objects*. Milan: Skira, 2003.

Latour, Bruno, and Peter Weibel, eds. *Making Things Public: Atmospheres of Democracy*. Cambridge, MA: MIT Press, 2005.

Lehanneur, Mathieu, and David Edwards, eds. *Bel-air: News about a Second Atmosphere*. Paris: Édition Le Laboratoire, 2007.

Lindemann Nelson, Hilde, ed. *Stories and Their Limits: Narrative Approaches to Bioethics*. New York: Routledge, 1997.

Luckhurst, Roger. *Science Fiction*. Cambridge, UK: Polity Press, 2005.

Lukić, Branko. *Nonobject*. Cambridge, MA: MIT Press, 2011.

MacMinn, Strother. *Steel Couture—Syd Mead—Futurist*. Henrik-Ido-Ambacht: Dragon's Dream, 1979.

Manacorda, Francesco, and Ariella Yedgar, eds. *Radical Nature: Art and Architecture for a Changing Planet 1969-2009*. London: Koenig Books, 2009.

Manaugh, Geoff. *The BLDG Blog Book*. San Francisco: Chronicle Books, 2009.

Mandel, Mike, and Larry Sultan. *Evidence*. New York: Distributed Art Publishers, 1977.

Manguel, Alberto, and Gianni Guadalupi. *The Dictionary of Imaginary Places*. San Diego: Harcourt, 2000 [1980].

Marcoci, Roxana. *Thomas Demand*. New York: Museum of Modern Art, 2005.

Martin, James. *The Meaning of the 21st Century: A Vital Blueprint for Ensuring Our Future*. London: Transworld Publishers, 2006.

Mass Observation. *Britain*. London: Faber Finds, 2009 [1939].

Mead, Syd. *Oblagon: Concepts of Syd Mead*. Pasadena: Oblagon, 1996 [1985].

Metahaven, and Marina Vishmidt, eds. *Uncorporate Identity*. Baden: Lars Müller Publishers, 2010.

Miah, Andy, ed. *Human Future: Art in an Age of Uncertainty*. Liverpool: Fact/ Liverpool University Press, 2008.

Michael, Linda, ed. *Patricia Piccinini: We Are Family*. Surry Hills, Australia: Australia Council, 2003.

Midal, Alexandra. Design and Science Fiction: A Future without a Future. In *Space Oddity: Design/Fiction*, ed. Marie Pok, 17-21. Brussels: Grand Hornu, 2012.

Miéville, China. *Railsea*. London: Macmillan, 2012. Kindle edition.

Miéville, China. *The City and the City*. London: Macmillan, 2009.

Mitchell, Timothy. Hydrocarbon Utopia. In *Utopia/Dystopia: Conditions of Historical Possibility*, ed. Michael D. Gordin, Helen Tilley, and Gyan Prakish, 117–147. Princeton, NJ: Princeton University Press, 2010.

Momus. *Solution 11–167: The Book of Scotlands: Every Lie Creates a Parallel World. The World in Which It Is True*. Berlin: Sternberg Press, 2009.

Momus. *Solution 214–238: The Book of Japans: Things Are Conspicuous in Their Absence*. Berlin: Sternberg Press, 2011.

More, Thomas. *Utopia*. Trans. Paul Turner. London: Penguin Books, 2009 [1516].

Morris, William. *News from Nowhere*. Oxford: Oxford University Press, 2009.

Morrow, James, and Kathryn Morrow, eds. *The SFWA European Hall of Fame*. New York: Tom Doherty Associates, 2007.

Moylan, Tom. *Demand the Impossible: Science Fiction and the Utopian Imagination*. New York: Methuen, 1986.

Museum Folkwang. *Atelier Van Lieshout: SlaveCity*. Köln: DuMont Buchverlag, 2008.

Nicholson, Ben. *The World, Who Wants It?* London: Black Dog Publishing, 2004.

Niermann, Ingo. *Solution 1–10: Umbauland*. Berlin: Sternberg Press, 2009.

Noble, Richard. *Utopias*. Cambridge, MA: MIT Press, 2009.

Noble, Richard. The Politics of Utopia in Contemporary Art. In *Utopia & Contemporary Art*, ed. Christian Gether, Stine Høholt, and Marie Laurberg, 49–57. Ishøj: ARKEN Museum of Modern Art, 2012.

Oatley, Keith. *Such Stuff as Dreams: The Psychology of Fiction*. Oxford: Wiley-Blackwell, 2011.

Office Fédéral de la Culture, ed. *Philippe Rahm and Jean Gilles Décosterd: Physiological Architecture*. Basel: Birkhauser, 2002.

Ogden, C. K. *Bentham's Theory of Fictions*. Paterson, NJ: Littlefield, Adams & Co., 1959.

Osborne, Peter. *Conceptual Art*. London: Phaidon, 2005 [2002].

Parsons, Tim. *Thinking: Objects—Contemporary Approaches to Product Design*. Lausanne: AVA Publishing, 2009.

Pavel, Thomas G. *Fictional Worlds*. Cambridge, MA: Harvard University Press, 1986.

Philips Design. *Microbial Home: A Philips Design Probe*. Eindhoven: Philips Design, 2011.

Pohl, Frederik, and Cyril Kornbluth. *The Space Merchants*. London: Gollancz, 2003 [1952].

Priest, Christopher. *Inverted World*. London: SF Gateway, 2010 [1974]. Kindle edition.

Rancière, Jacques. *The Emancipated Spectator*. London: Verso, 2009.

Reichle, Ingeborg. *Art in the Age of Technoscience: Genetic Engineering, Robotics, Artificial Life in Contemporary Life*. Vienna: Springer-Verlag, 2009.

Ross, Richard. *Architecture of Authority*. New York: Aperture Foundation, 2007.

Sadler, Simon. *Archigram: Architecture without Architecture*. Cambridge, MA: MIT Press, 2005.

Sainsbury, Richard Mark. *Fiction and Fictionalism*. London: Routledge, 2009. Kindle edition.

Sargent, Lyman Tower. *Utopianism: A Very Short Introduction*. Oxford: Oxford University Press, 2010.

Saunders, George. *Pastoralia*. London: Bloomsbury, 2000.

Schwartzman, Madeline. *See Yourself Sensing: Redefining Human Perception*. London: Black Dog Publishing, 2011.

Scott, Felicity D. *Architecture or Techno-utopia: Politics after Modernism*. Cambridge, MA: MIT Press, 2007a.

Scott, Felicity D. *Living Archive 7: Ant Farm: Allegorical Time Warp: The Media Fallout of July 21, 1969*. Barcelona: Actar, 2007b.

Self, Will. *The Book of Dave*. London: Bloomsbury, 2006.

Serafini, Luigi. *Codex Seraphinianus*. Milan: Rizzoli, 2008 [1983].

Shteyngart, Gary. *Super Sad True Love Story*. London: Granta, 2010. Kindle edition.

Sim, Stuart, and Borin Van Loon. *Introducing Critical Theory*. Royston, UK: Icon Books, 2004.

Simon, Taryn. *An American Index of the Modern and Unfamiliar*. Göttingen: Steidl, 2007.

Skinner, B. F. *Walden Two*. Indianapolis: Hackett Publishing, 1976 [1948].

Spector, Nancy. *Mathew Barney: The Cremaster Cycle*. New York: Guggenheim Museum, 2002.

Spiller, Neil. *Visionary Architecture: Blueprints of the Modern Imagination*. London: Thames & Hudson, 2006.

Spufford, Francis. *Red Plenty*. London: Faber and Faber, 2010. Kindle edition.

Strand, Clare. *Monograph*. Göttingen: Steidl, 2009.

Suárez, Mauricio, ed. *Fictions in Science: Philosophical Essays on Modeling and Idealization*. London: Routledge, 2009.

Talshir, Gayil, Mathew Humphrey, and Michael Freeden, eds. *Taking Ideology Seriously: 21st Century Reconfigurations*. London: Routledge, 2006.

Thaler, Richard, and Cass Sunstein. *Nudge: Improving Decisions about Health, Wealth, and Happiness*. London: Penguin, 2009.

Thomas, Ann. *The Photography of Lynne Cohen*. London: Thames & Hudson, 2001.

Thomson, Rupert. *Divided Kingdom*. London: Bloomsbury, 2006.

Tsuzuki, Kyoichi. *Image Club*. Osaka: Amus Arts Press, 2003.

Tunbjörk, Lars. *Office*. Stockholm: Journal, 2001.

Turney, Jon. *The Rough Guide to the Future*. London: Rough Guides, 2010.

Utting, David, ed. *Contemporary Social Evils*. Bristol: The Policy Press/Joseph Rowntree Foundation, 2009.

Vaihinger, Hans. *The Philosophy of "As if": Mansfield Centre*. Eastford, CT: Martino Publishing, 2009 [1925].

Van Mensvoort, Koert. *Next Nature: Nature Changes Along with Us*. Barcelona: Actar, 2011.

Van Schaik, Martin, and Otakar Má el, eds. *Exit Utopia: Architectural Provocations 1956-76*. Munich: Prestel Verlag, 2005.

Wallach, Wendell, and Colin Allen. *Moral Machines: Teaching Robots Right from Wrong*. Oxford: Oxford University Press, 2009.

Walton, Kendall L. *Mimesis as Make-Believe: On the Foundations of the Representational Arts*. Cambridge, MA: Harvard University Press, 1990.

Winner, Langdon. *The Whale and the Reactor: A Search for Limits in an Age of High Technology*. Chicago: University of Chicago Press, 1986.

Williams, Gareth. *Telling Tales: Fantasy and Fear in Contemporary Design*. New York: Harry N. Abrams, 2009.

Wilson, Stephen. *Art + Science: How Scientific Research and Technological Innovation Are Becoming Key to 21st-century Aesthetics*. London: Thames & Hudson, 2010.

Wood, James. *How Fiction Works*. London: Jonathan Cape, 2008.

Wright, Erik Olin. *Envisioning Real Utopias*. London: Verso, 2010.

Wyndham, John. *The Chrysalids*. London: Penguin, 2008 [1955].

Yokoyama, Yuichi. *New Engineering*. Tokyo: East Press, 2007.

Yu, Charles. *How to Live Safely in a Science Fictional Universe*. London: Corvus, 2010.

Žižek, Slavoj. *First as Tragedy, Then as Farce*. London: Verso, 2009.

INDEX

Page numbers in italics refer to illustrations.